D1003169

PEWABIC POTTERY

PEWABIC POTTERY

A HISTORY HANDCRAFTED IN DETROIT

CARA CATALLO

THE
History
PRESS

Published by The History Press
Charleston, SC
www.historypress.net

Front cover, top: The loggia at the Detroit Public Library's Main Library. *Courtesy of Pewabic Pottery*. *Front cover, bottom*: Pewabic giftware, including a large petite vase in metallic, a classic vase in iridescent and a Pewabic pint in cinnamon. *Courtesy of Pewabic Pottery. Photo by Scott Lane. Back cover, inset*: A young Mary Chase Perry Stratton decorates a vase at the Stable Studio, from the February 1905 *Keramic Studio. Courtesy of Pewabic Pottery*.

First published 2017

Manufactured in the United States

ISBN 9781467137201

Library of Congress Control Number: 2017934930

Notice: The information in this book is true and complete to the best of our knowledge. It is offered without guarantee on the part of the author or The History Press. The author and The History Press disclaim all liability in connection with the use of this book.

Dedicated to the memory of Mary Chase Perry Stratton, with gratitude for her determination and dedication and for sharing her gifts with Detroit and the world.

And to the memory of another strong Detroit woman, my grandmother Elizabeth Lutz Hanson.

Finally, to my mother for her shining moments of tolerance for her youngest child, and to Bird, with hope she nurtures within herself remarkable attributes—fortitude, resilience and strength of character—such as these women so beautifully exemplify.

CONTENTS

ACKNOWLEDGEMENTS

Pewabic Pottery's roots run deep in Detroit. Somehow, they run deep within me too.

Not in any obvious way—I'm no relation to founders Mary Chase Perry Stratton or Horace James Caulkins, nor am I a ceramicist or pottery expert, although I hold great affection for my high school ceramics teacher Susie Symons and college professor John Kingston. No, for me, it's that my own roots tunnel deep into soil not far from the East Jefferson pottery building.

Pewabic's founders already had invested almost a quarter of a century into their collaboration when my grandmother was born roughly a mile away. She'd grow up picnicking at Water Works Park across the street from the English-style pottery building and grew to admire Pewabic's telltale craftsmanship and beautiful lustrous glazes, quietly treasuring each tile she saved up to buy.

Two generations later, I found myself in that same space on Jefferson, with my daughter throwing pieces on the wheel in the education studio. I looked around and wondered about the historic building that somehow survived a century that proved to be, at times, as gritty at it gets.

I set out to learn what I could about Pewabic so that people like me who find themselves captivated by the space and the glisten of the glazes born there could know more. What I found was minimal—a piecemeal assortment of information collected through the years. Gaps and contradictions were aplenty, although Pewabic's archives department offered a good handle on some of Perry Stratton's history, thank goodness, so I set out to tell the

story of the ceramicist and her successful benefactor who came together to form an art business that would become a recognizable thread in the fabric that is Detroit. And as Detroit renews itself, Pewabic Pottery is still going strong, having outlasted so much around it as the world sped into the manufacturing age.

No words can adequately convey my gratitude to the people who are today's Pewabic for graciously opening its doors to me. Truth be told, I'm not special—these artisans warmly share their work with visitors every day. They regularly pause to answer questions from curious onlookers about everything from the historic clay-making equipment to the modern-era kilns and let folks watch as they work pressing a tile or glazing a vessel. These aren't reenactors. They're the real deal, practicing their craft similarly to how their predecessors did back in 1903. From the designers to the tile pressers, glaze and kiln technicians, all the way to those who market, sell and ship the giftware and the educators who usher in the next generation artisans, thank you.

Exceptional thanks to Pewabic's Steve McBride, executive director, and Kimmie Dobos, archivist, and to the following people who provided images and expertise, oftentimes both: Amanda Rogers, Jason Keen, Cybelle Codish, Scott Lane, Geraldine Rohling, Jeff Gaydash, Sara Garbarini, Doug Stratton, David McKeehan and Leslie Edwards.

Finally, my thanks to those who preceded me, sharing Pewabic's story or recollections of Perry Stratton or Caulkins, whether in newspapers, magazines, correspondence or a smattering of books through the years, each helping to reveal some pertinent piece of the puzzle. No history is complete. Too many variables lurk in the unknown, and details inevitably die with people, go missing as figureheads change or remain buried or tucked away in private collections. Artifacts and ephemera get pilfered or scattered between buildings and people, making it harder to piece history together with any confidence to know conclusively what came before. What's new and exciting for one may be old hat to another historian. We know enough to paint a broad stroke well appreciative of Caulkins and Perry Stratton and the pottery they brought to life, as well as about the building William Buck Stratton designed for them. Perhaps most importantly, we can see that Pewabic's story continues to be written.

INTRODUCTION

The twentieth century was still young when Mary Chase Perry and Horace J. Caulkins decided to transform a vacant carriage house in their Brush Park neighborhood into a pottery. At first glance, the partnership between the two Detroit neighbors likely seemed implausiblw.

It wasn't. The artisan and art-loving visionaries, both having already found successes in earlier careers, pooled their talents together to create Pewabic Pottery, dedicating it to the ideals of the Arts and Crafts movement and the perpetuation of non-standardized forms in a place that would soon be synonymous with industrialization and mechanization—the Motor City.

Pewabic Pottery went on to become celebrated within Detroit and beyond, garnering Perry Stratton notoriety for voluminous architectural tile installations and rich iridescent glazes, reaching heights with noted art collectors like Charles Lang Freer, who reportedly predicted, "Hundreds of years from now the name of your motor cars and drug factories may be forgotten, but people will know that Pewabic Pottery was made in Detroit because this beauty will live."

More than a century later, the name Pewabic remains a familiar calling card of Detroit craftsmanship, recognizable on buildings like Detroit's historic Guardian Building and the Detroit Public Library's loggia, as well as the not-so-old Old English "D" tiles that practically encase Comerica Park, built in 2000 to house the Detroit Tigers, and the M1 Rail QLine stations, new in 2017. Pewabic's prevalence on and in commercial buildings; public

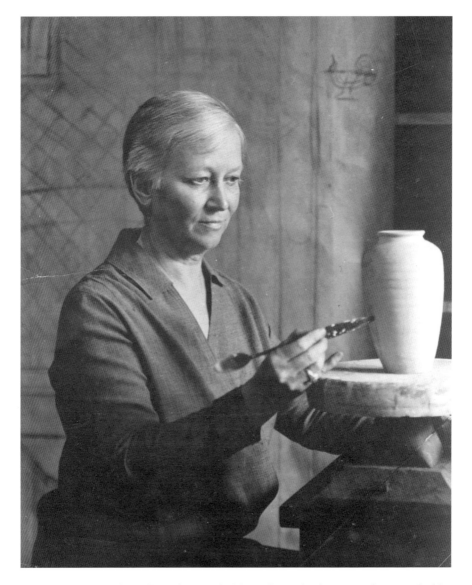

This image of Mary Chase Perry Stratton incising a decoration into a vessel appeared with a *New York Times* profile of Pewabic Pottery's founder that ran on April 7, 1940. *Courtesy of Pewabic Pottery.*

institutions like schools and libraries; ecclesiastical structures; and fireplaces, backsplashes and bathrooms in countless residences makes inclusiveness here impossible. The examples are so many that some would inevitably be excluded, and often people mistake other tile work for Pewabic, when it

could be another of the era, such as Flint Faience, the tile company that started from the kilns that made Champion spark plugs.

Life at Pewabic wasn't always easy. During the Great Depression, it struggled like much of the country. The times almost echoed Father Gabriel Richard's Detroit motto from an earlier century—*Speramus meliora*; *resurget cineribus* (Latin for "We hope for better things; it will rise from the ashes")— as work almost came to a standstill. Detroit's ceramic spirit managed to keep going because its dedicated craftspeople kept it alive. Later, after the deaths of its founders, Pewabic practically became dormant, and the threat of closing loomed heavy until its devotees stepped up to create the nonprofit Pewabic Society to ensure that they could hand it off to the next generation of watchful caretakers and artisans. For them, the ashes Richard references are those at the bottom of Caulkins's kiln, remnants of apple trees neighbors delivered to Pewabic because Perry Stratton reportedly liked how long the apple wood burned and the fragrance it diffused throughout the neighborhood.

Pewabic is a complicated maze of prolific work in and around Detroit and beyond. At the outset, history may not seem fluid, but it is. Even with Perry Stratton's unpublished autobiography as a basis and key players long gone, previously unknown details emerge. Perry Stratton wasn't thorough when it came to including dates—she recorded information in her daybooks sometimes thoroughly and sometimes less so—and jobs sometimes took years to complete from initial designs to creating and finally installing. Through the years, material went missing and Pewabic lost large pieces of its history. Fortunately, many historic images, correspondence and pottery remain as stellar examples of what came before, while other priceless items exist in museum collections because of the wise considerations of Pewabic's key players and other longtime supporters like Charles Lang Freer and George Booth, who wisely donated pieces to the DIA, to museums they established and elsewhere. And significant artwork and ephemera of Perry Stratton's life exist in private collections.

Pewabic installations go well beyond Detroit—in private homes, in and on too many churches to count and on campuses from Michigan State University and the University of Michigan to Oberlin College and all the way to Rice University in Houston. But this book focuses on Pewabic in Detroit and, in some cases, metropolitan Detroit. That's because Pewabic is Detroit.

Throughout it all, Perry Stratton's steadfast focus remained the pottery itself and on supporting the arts as a whole. When honored, she deflected all accolades directed her way back toward the importance of art.

Whatever tinge of recollection the name Pewabic ignites—whether from a public installation, a beautiful hand-thrown vessel or single pressed tile that hangs in a relative's house—it's about a Detroit business and products handmade on Jefferson by hardworking, dedicated craftspeople, earning author Marion Nelson's description of Pewabic as a "bastion of handcraftsmanship."

MARY CHASE PERRY

"Born a dau."

The busy mining town doctor did not elaborate when he recorded the words uneventfully, noting the birth on March 15, 1867, as he had so many before with a simple "Born a dau."

Mary Chase Perry was his own daughter, born to Dr. William Walbridge Perry, MD, and his wife, Sophie Barrett Perry. The subdued three-word notation fell short of the "meticulously detailed" births recorded for her older siblings, Frederick and Gertrude, as a grown Mary Chase would reflect many years later in her unpublished autobiography, "Adventures in Ceramics: The Story of Mary Chase Perry and The Pewabic Pottery."

From as far back as she could recall, young Mary Chase took stock of the world around her, even in those earliest days in Hancock, Michigan, established only seventeen years before her birth.

William Perry seemed a solemn, religious man, although his past showed glimmers of adventure. He earned an undergraduate degree from University of Michigan in 1842 and then attended Rush Medical College in Chicago before setting out in 1851 to experience the California Gold Rush and Australia's gold rush in 1852. Four years later, he returned to the United States, and in 1858, Perry married Sophie Barrett in Superior, Wisconsin. Not long after the birth of son Fred, the family moved to Michigan's northernmost city atop the Keweenaw Peninsula, an area the doctor knew reasonably well from sailing Lake Superior when he was young.

Growing up in Hancock, young Mary Chase entertained herself with the minutiae of her surroundings. Colors caught her attention—a blood-red cut of rare beef, the spellbinding "ingenious patterns" encapsulated in a kaleidoscope, a raised lamb design on a china vase—igniting thoughts about "the relation of beauty and utility" in day-to-day life. She later wrote how she believed she subconsciously stored away design notes even in her earliest childhood, as well as how colors flooded back to her in rich details when the time was right: memories of the great walls of white snow that lined the wintry streets like "endless marble halls"; nearby Portage Lake's "warm coppery red in summer"; and "a bright green" like the coat her first doll wore.

"Colors affected me tremendously, making for cheer or gloom in my surroundings as well as in my childish mental outlook," wrote Perry Stratton years later, recalling her mother using ink-covered toothbrushes to create spatter art with her daughter's namesake, an artist friend named Mary Chase. The young Mary Chase preferred sculpture and took to forming small figurines from the area's red clay.

Then, in 1877, everything changed in an instant for the Perry family. A disgruntled traveler mistook Dr. Perry for the train conductor with whom he had quarreled earlier that day and bludgeoned the doctor with an axe handle. Unable to recover, he died the following spring.

Following the death of her husband, Sophie Perry scrambled to make ends meet for her three children. Determined to contribute to the family coffer, her youngest daughter quietly set out to sell brass lamp burners for thirty-five cents in the nearby shantytown. The family quickly caught on and put an end to her industrious efforts.

The Perry family left the Upper Peninsula to move downstate to Ann Arbor, for Fred to attend his father's alma mater. There the family's spacious house accommodated other young men who retreated from mining country in pursuit of an education, in turn helping to support the Perry household. For Mary Chase, Ann Arbor provided a rich intellectual atmosphere. She wrote that the dome that topped the literary department "stood for all culture" in her young eyes and that walking the campus felt like tracing the steps of her heritage, creating a connection not only to her late father but also to his father, William Riley Perry, who reportedly came to Ann Arbor from Cayuga County, New York. The elder Perry reportedly was admitted to the bar in 1842 and served as justice of the peace and justice of the circuit court before moving to Wisconsin in the early 1850s.

Young Mary Chase's artwork began to take flight. Sophie Perry quickly recognized her daughter's talent in a small watercolor painting of a robin on a berry-covered branch. She retrieved Bristol-board paper that belonged to her late husband and at thirty-three and a third cents per lesson—or three for a dollar—hired her daughter's first formal art teacher, a local artist named Lily Chase. Perry Stratton later wrote in her autobiography:

> *Under Lily Chase's guidance I painted a snow scene, including a small yellow house with a thatched roof and low lying clouds in a rich blue sky. The air was filled with flakes of snow that vied with the smoke from the chimney. At home we all looked upon it with awe, and my own judgement was quite impersonal—I thought it was as good as the original from which it was copied. It was promptly framed in a gilded moulding and hung over the piano—pretty high for me but still I could stand before it and feel the urge of the budding artist.*

It was only the beginning. Mary Chase began to paint flowers and landscapes on silk, other materials and on eggshells, and soon she started selling hand-painted Christmas cards at the local bookstore.

When Fred Perry finished his pharmacy training in Ann Arbor, the family moved to Detroit, where he became a druggist. Detroit opened even more doors for thirteen-year-old Mary Chase to explore art, but none rivaled the camaraderie she found with landscape artist Colonel Charles M. Lum.

A Civil War veteran wounded in the Battle of Bull Run in 1861, Lum came to Detroit to recuperate and lived in what eventually became the first Harper Hospital, "when it still occupied the old barracks out Woodward Avenue," as Perry Stratton later described. Art filled every inch of Lum's room. She had never known any space like it. Lum opened the young artist's mind in new ways as he taught his charge about colors and shadows and even served as the subject of her first charcoal portrait.

Lum also told the story of the late Harper Hospital founder Nancy Martin, "the brave market woman who did so much for her city—and the fact that it was a woman who first conceived civic responsibility in Detroit," wrote Perry Stratton, possibly suspecting that if Martin, who had died in 1875, could do so much for the city, so could she.

With Lum's instruction and encouragement, Perry Stratton enlisted in correspondence courses to further her artistic skills. Eager to move ahead, she even occasionally mailed off still-damp paintings. Her determination paid off with a third-place prize, a monogramed leather portfolio that

included a set of miniature oil paintings by the artist William Paul Brown. The recognition reiterated to the young artist to keep going. This was only the beginning.

It wasn't until years later, upon Lum's death on September 8, 1899, that she realized the significance of his service in the Tenth Regiment Michigan Infantry on the Civil War front, writing, "The remembrance of his brave deeds was like an ember in the hearts of his townsmen, which burst into flame at the news of his passing."

CHINA PAINTING AND THE CURIOUS NEIGHBOR WITH THE KILN

"The forerunner of the craft to which I have devoted most of my life."

With the support of her family and confidence instilled by Lum, Perry Stratton attended the Cincinnati Art Academy in 1887–89. There she studied with noted Italian American sculptor Louis Rebisso and also experienced a greater taste of china painting, an art style made popular in Europe after the 1867 Paris World Exhibition and that reached greater American prominence a decade later following Philadelphia's Centennial Exposition in 1876. She was a natural, especially in her ability to mix the decorative mineral colors to apply to the china pieces.

In Cincinnati, she studied alongside notable china painters and budding potters Maria Longworth Nichols, founder of Rookwood Pottery, and Adelaide Alsop Robineau, who went on to start the magazine *Keramic Studio*. Although clearly talented in the medium, Perry Stratton considered china painting to be the "prevailing fad" and soon counted herself among the china painters caught between continuing to practice and master that art form or focusing on becoming potters, a field that they suspected would bring not only greater respect and credibility as artists but also greater fulfillment.

After Perry Stratton completed her studies in Cincinnati, she returned to Detroit for a year to study at the Detroit Museum of Art school before moving to the arts-rich community of Asheville, North Carolina, to teach china painting. In 1893, Perry Stratton returned to Detroit to open a small china painting studio at 6 West Adams with three friends she knew from the

city's art academy. Perry Stratton continued to excel at china painting and later recognized this time as a pivotal moment in her career, describing it as the "forerunner of the craft to which I have devoted most of my life."

Back in Detroit, at the Perry family's rented furnished house on Edmund Place in the city's Brush Park neighborhood, Perry Stratton found herself noticing certain idiosyncrasies of the family next door, as she described in her autobiography:

> *It was such a complex group that it could not help arousing our interest when various members strolled around the yard, or scrambled into their low victoria. The father of the family was punctilious about dressing in a proper way befitting Sunday. We would see him coming down the steps ready for church, with his buttoned Prince Albert coat and high hat....Little did I dream the influence this family was to have on my future.*

The family patriarch was none other than Horace James Caulkins. Born July 12, 1850, in Oshawa, Ontario, Canada, Caulkins moved to Detroit in 1871, finding work as a salesperson at the George Peck & Company store. In 1877, he became half of Prittie & Caulkins, a drug and dental supply company. At that time, he was married to Frances Leadbetter, with whom he had a son, Edward, before her death in 1878. The following year, he sold the drugstore side of the business to Prittie and renamed the rest Detroit Dental Depot.

In 1888, ten years after the death of his first wife, Caulkins married Minnie Frisbie Peck, daughter of his former employer. The pair had seven children.

The dental appliance business suited Caulkins, a founding member and former president of the American Dental Trade Association. By 1892, Caulkins had become acquainted with Detroit dentist Charles Land, DDS, credited with inventing gold and porcelain artificial teeth. Although some would dispute which man did, one or both together designed or at least manufactured a high-firing kiln that fired porcelain dental ware without causing it to discolor. At least one personal account—a letter Mrs. Albert Nebe wrote to Louise Orth, dated October 13, 1932—recalled that Perry Stratton worked in Land's office for some time.

China painters used these same kilns to, in effect, seal their painted pieces. Perry Stratton found such "great success with it" that she frequently showed her work to Caulkins's prospective customers. Next, Caulkins manufactured a portable, kerosene oil–fueled muffle kiln patented on January 5, 1897, by Egle Bros. in Detroit. The kiln included fire-brick construction and a tubular lining and could reach heats in excess of 2400 degrees Fahrenheit, suitable for

firing porcelain and china. Marketed as a "practical working furnace," the kiln was less expensive to fire than conventional cast-iron models. Its comparative affordability, compact design and safety features—a hinged door and peephole—made the kiln a viable alternative to china painters like Perry Stratton. Because these kilns offered revelatory enhancements and abilities, their name became Revelation Kilns.

In a September 8, 1950 letter she wrote to ceramicist Glen Lukens, Perry Stratton described her contribution to Revelation Kilns "as one of the original workers with the idea of vaporized kerosene. Of course it was applied first for lower heat for overglaze decoration. Very soon it was used in manufacturing

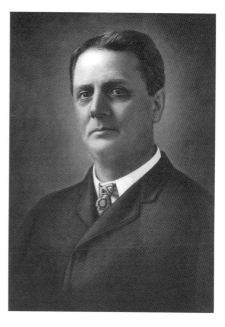

Portrait of Horace Caulkins. *Courtesy of Pewabic Pottery.*

porcelain for dental purposes....I cannot claim to be the inventor of the system as it was the result of collaboration with Mr. Caulkins and other mechanically minded friends. I can say that its application to certain phases of reduction came from my own experiments."

Perry Stratton quickly became a respected teacher and leader within the National League of Mineral Painters and traveled widely to demonstrate china painting and pen magazine critiques and articles, including for Robineau's *Keramic Studio*. The travel brought experiences that not only furthered Perry Stratton's own china painting but she trained others by way of demonstrations that could sell Revelation Kilns in the process. In the late 1890s, she had crisscrossed the eastern part of the United States from as far south as Atlanta all the way north to St. Paul, Minnesota, and at least as far west as Omaha, Nebraska. The results from her demonstrations, as noted in her autobiography, enticed china decorators into being kiln buyers:

> *After another visit to the kiln, the colors became brilliant and sparkled. The raised paste which was dull at first, became shining and goldy, after being burned with a glass brush or agate burnisher. The whole effect had its appeal, and most women and men too, of that period, had a great admiration for decorated ware.*

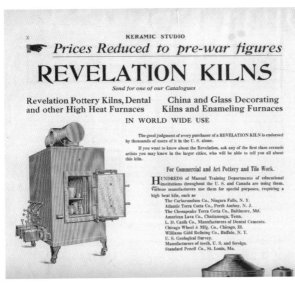

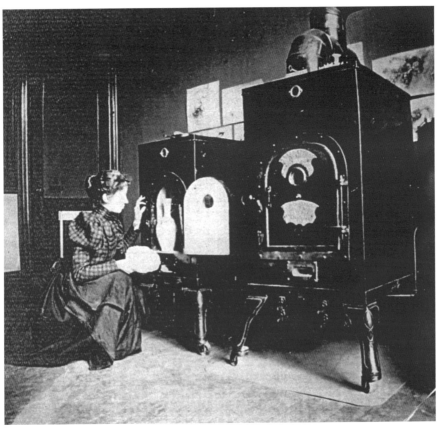

Left: A Revelation Kilns ad that appeared in an issue of *Keramic Studio*. *Courtesy of Pewabic Pottery.*

Below: Mary Chase Perry poses with two Revelation Kilns—Kiln No. 5, *on the left*, reportedly sold for $81.50, while the nearby No. 6 cost $96.50—likely in conjunction with a china painting demonstration. The watercolors hanging behind the kilns were studies used in demonstrations and classes. *Courtesy of Pewabic Pottery.*

Even with the accolades and reasonable compensation she received, Perry Stratton grew tired of the travel. She also knew by then that china painting lacked the permanent role she sought because of what she considered its "superficial contact with an art or a craft." Her star, she wrote, "still beckoned on." What she longed to do was experiment with glazes, but she had yet to determine the proper avenue to best do so. Perry Stratton found herself at a crossroads, describing herself as restless and artistically unfulfilled. Faced with two clear opportunities before her—running an art department at a girls' school or working full time at a ceramics magazine—she joined the Caulkins family at their cottage across the Canadian border in Lake Erie's Rondeau Point, Ontario, hoping her friends' guidance would aid in her decision-making. While Horace Caulkins was seventeen years her senior, his wife, Minnie, was only a year older than Perry Stratton, and the two women reportedly had become close friends.

One morning at Rondeau, as Perry Stratton strolled the shoreline, a gust of wind blew a newspaper across her path. The headline caught her eye: "Why Not Develop the Resources of the United States?" The article exalted America's natural resources—clay, copper, zinc and lead—and profiled a clay-working school. Perry Stratton instantly felt that she had found her place in the world. "At once I was illumined—I ran—I flew. Breathless, I kept on running until I could see Mr. Caulkins standing outside their cottage, shading his eyes with hand, looking up and down the beach," recounted Perry Stratton in her memoirs.

She told Caulkins about her epiphany. Before she could even get the words out to ask for his help, he offered. With his own successful career for the most part behind him, Caulkins shifted to help hers.

"No other human whom I have known would have recognized the unfolding of an idea of which he was willing to be a part," she recalled about Caulkins and his resolve and support for Perry Stratton. In return, she did not take lightly his faith in her, writing in her autobiography:

> *I have little idea that he believed we would continue very far, but he brought a zest, with which he, in turn, invested over our small beginnings— and how small they were. I had superficial training in certain forms of decorative art, hazy visions of a development connected with clay, yet my whole thought was possessed by the idea of taking definite steps, which would leap forward. It all sounds very much like a chimera when compared to the standardized and scientific methods of today.*

Perry Stratton's future began to take shape. The next step toward making their venture a reality was to educate themselves on this new artistic endeavor. They knew china painting—and what firing those pieces entailed—but working with malleable clay instead of decorating and firing already glazed porcelain was new to both Perry Stratton and Caulkins, even if some of the materials were the same or similar.

Soon she began to research the fundamentals of clay and began to experiment with materials. She recalled those earliest attempts at making clay formulae in her memoirs: "They were weighed out, ground in mortar, dried into little slabs, placed in a small muffle of a little kiln and carried to an impossible heat. It was a fired puddle. That was all. A melted globule like a small hard pebble. Next one ingredient at a time was doubled. Then increased five times, then ten times."

Through trial and error, Perry Stratton learned the distinctive characteristics each material offered: spar brought translucence, kaolin was temperamental during the firing process and ball-clay offered greater plasticity pre-firing but greater toughness afterward. She learned how seger cones—small clay pyramids placed near samples, measuring heat in twenty-degree increments, from two hundred degrees Fahrenheit to more than three thousand degrees Fahrenheit—act as the standard bearer to test formulae, materials and for determining kiln temperatures.

"It must be plastic enough for modeling or building by hand, to be thrown on the wheel or to be pressed in a plaster-of-Paris mould. I had gained these desirable points from reading about processes," she noted.

With Perry Stratton focused on the clay and other mixtures to determine how best to accomplish the effects she wanted, Caulkins concentrated on the financial aspects of the business, as well as kiln temperatures and fuels. Trial after trial, Perry Stratton modified formulae, materials, firing temperatures and burn times. Initially, they used a small kerosene oil kiln with a three- by six-inch muffle developed for dental use. Caulkins still maintained his other business, but seemed to enjoy taking part in evolution of the pottery, especially the firing process and inspecting the results as they emerged from the cooled kiln.

Determined to learn all she could, Perry Stratton appreciated spending time with other artists to better comprehend techniques, theories and anything that might be pertinent to making her new venture a success. One such person was William Buck Stratton. The Cornell University–educated architect was tall and thin, and although she described him as direct, she also assessed that he was "not entirely articulate in the spoken

word" and mystified with her "seemingly trifling little pottery shapes. It was difficult to foresee any importance in what I was doing," she wrote. Stratton brought a more formal grasp of design principles, fundamentals that she worried she lacked. In return, she helped Stratton embrace greater freedom of expression.

"If only an understanding of the rudiments of art and architecture had been transferred from his mind to mine!" Perry Stratton wrote. "At the time he was dreaming of tall spires and Grecian columns, I was starting to play with innocuous cups and saucers, but I was thinking ahead."

Later in her memoirs, she warmly recalled spotting the tall, thin Stratton amid a procession of Michigan Naval Brigade sailors from the USS *Yosemite*, which navigated the captured Spanish ship the *Juan de Austria* up the St. Lawrence to Detroit.

Perry Stratton and Caulkins dedicated roughly a year to determine the appropriate clay mix that would consistently meet their requirements and maintain the necessary consistency. Perry Stratton shaped little clay pieces by hand to run the clay and kiln experiments and learned to make one- and two-part plaster-of-Paris forms. She found casting—pouring watered-down clay into a mold—"simple and fascinating" and wrote in her autobiography about the "miracle" that happens:

> *The plaster form sucks up a certain amount of water, causing a thin wall of clay to adhere to it. When the wall appears thick enough, the surplus slip is poured out, and after a few moments, a sure-enough little jar or bowl is jiggled out of the mould. Common practice in potteries, but a great achievement for a beginner.*

Once she had a handle on the basics of clay and mold-making, Perry Stratton began to fashion small shapes that would, as she said, serve her next great purpose: "to receive glazes and colors and what-not treatment to point us on our way." Her focus forward turned to the glazes that would define her pottery for decades to come. She described herself as fraught with excitement, recalling, "We hadn't the slightest idea of our ultimate."

Like when she worked to determine the correct clay composition, discovering a glaze formula was another process of trial and error. Perry Stratton and Caulkins mixed and remixed ingredients, brushing results on samples and modifying combinations. A book from her late father's library helped lead Perry Stratton to better understand which mineral oxides and carbonates at what percentages could achieve certain colors. She reveled in

learning firsthand the resulting fluctuations. Experiments fascinated her and taught her how to accomplish various glaze effects, including transparency and the bright hues she loved so much. She wrote how she found that by adding tin oxide she could produce an opaque glaze she later recognized as white enamel. She relished each discovery, writing that after she "hastily sprinkled a little black oxide of cobalt around the top edges of a small bowl previously covered with the clear glaze," they received their first successful color: blue around the top that spilled over the sides. "Our hearts rejoiced."

From that point on, Perry Stratton meticulously weighed materials and recorded temperatures, times and results to ensure that they could reproduce effects they discovered. She continued to alter ingredients and quantities in search of characteristics she hoped would define her pieces, noting in her autobiography, "One percent of copper added to a glaze proved to be pale green—larger amounts made darker greens. Similarities with iron uranium, nickel and manganese gave a knowledge of their coloring properties. The same mixes gave a different shade when applied over red clay. All kinds of tricks were tried out."

Each discovery delighted the constantly inquisitive artist, fueling her to continue and always reach further. "Those tiny bowls not more than an inch high still spell rapture when I look in the case where they are hidden. They are still discoveries to me....Small as they were these first pieces had a distinction from the beginning," she wrote.

Perry Stratton and Caulkins would choose two or three samples that they liked best from these experiments and use those as they considered what to modify next, as well as to identify and select which ones outshone earlier pieces, with their eyes always on improving and honing their skills. Throughout these steps, Perry Stratton was grateful that the pottery business so well suited Caulkins, who showed natural instincts when it came to selecting texture, color and quality. She found him eager for the "aesthetic experience," a concept growing in popularity, propelled by the Arts and Crafts movement and by collectors like their friend Charles Lang Freer.

It was Freer who suggested that the pair hold on to the pieces that resonated with them the most, as examples on which they could reflectively measure Pewabic's progress. Few people influenced Perry Stratton more than Freer, the successful industrialist who amassed one of the foremost Asian art collections. Freer consistently yet playfully challenged her to reach new artistic heights. He encouraged and advised the prolific maker on shapes, hues and finishes to achieve, and it was through Freer that she became interested in the glazes of the Orient. The two would enthusiastically discuss

what he found or learned on his trips to Europe or Asia. Perry Stratton would learn from Freer that an effect she sought to achieve was something he looked for in pottery made a thousand years earlier.

Perry Stratton's transition from china painter to ceramicist was a smooth one. Her inquisitive nature fed her never-ending desire to learn new techniques and to evolve. With Freer's invaluable guidance—and the examples set by his unrivaled collection—she gravitated to simpler forms rather than the more decorative art nouveau shapes she designed initially. Instead, she began to focus on intricate glazes to inspire awe rather than relying on the vessel's form. Freer also encouraged her to expand her palette beyond matte earthy green, a color initiated by Boston-based Grueby Faience Company and echoed by many other Arts and Crafts potteries.

With each accomplishment, Perry Stratton and Caulkins inched ever closer toward officially opening their pottery business and needing a proper location beyond Caulkins's basement. With automobiles becoming more and more common, many Detroit stables began emptying, including one belonging to Alanson Fox on nearby Alfred Street. The Brush Park stable building—behind Fox's home, better known as the Ransom Gillis house—seemed the perfect location for the new pottery. Perry Stratton summoned up the courage to inquire, describing her initial doubts in her autobiography:

> *Why should he have been interested at once? A slenderish young woman, proposing an outlandish scheme of turning his recently vacated stable facing John R Street into an embryo pottery, attaching a kiln to a chimney, setting up mills to grind glazes; no one knew what next. Perhaps the very audacity of the proposition appealed to his ever-open mind.*

Fox agreed to lease the carriage house to Caulkins and Perry Stratton for eight dollars a month, payable every three months. Relieved, she wrote about her future unfolding: "How my heart welled up when I left, key in hand, to open the door of what became our first Pottery."

Caulkins and Perry Stratton went to work renovating their new space, complete with a studio, kilns and space for a gallery to show the fledgling pottery's products. As one of Caulkins's men installed a stove and a small kiln, he mentioned that his twelve-year-old son was looking for work. Fresh out of grammar school, Julius Albus became the pottery's first employee. He cleaned the mills, swept floors and kept the place organized, freeing Perry Stratton to dedicate her time to clay and glaze research. The small but

determined Albus shared Perry Stratton's hunger for know-how and quickly became an integral part of what had become known as the Stable Studio or Revelation Pottery.

Having Albus to watch over the shop enabled Perry Stratton to spend three weeks in 1901 studying with painter and ceramicist Marshal Fry and Charles Fergus Binns, founding director at the New York State School of Clay-Working, recently established in Alfred, New York. Securing what she considered to be "a scientific foundation" would help to ensure a successful future, she believed, but she couldn't spare the two or three years a formal education would require. Perry Stratton's "zeal for immediate adventure—sensible or otherwise" fueled her rush, although she admitted later that a slower, more methodical approach might have saved herself from "making many foolish mistakes." Or, she added, it might not have made any difference at all.

At Alfred, Perry Stratton conscientiously gleaned all that she could about pottery to build her own skill set. She learned traditions handed down by generations of potters and spent time with working potters to learn firsthand from those further along in the craft.

"Such glimpses into the daily experiences of other craftsmen in small workshops gave an insight of practical value to one who was just starting," she wrote. "A new zest was added to our renewed efforts back in the little barn-pottery in Detroit." Perry Stratton preferred hands-on learning and being able to distinguish romance from reality, taking note of what she did and did not want to instill in her own pottery and practice, always conscientious to remain original.

Although her time there was brief, Alfred provided the foundation she sought. In Binns she also found a mentor with a like-minded appreciation and understanding of ceramics and ceramics education. Largely considered to be the forefather of American studio ceramics, Charles Binns found Perry Stratton to be one of his most dedicated and influential students. He continued to be someone with whom she would consult whenever she had a difficult question pertaining to materials or faced a conundrum about glazes.

Now with training, formulae, materials and a workable space, Perry Stratton was ready to hire more employees to help the young Albus with production. Through word of mouth, she learned of Joseph Heerich, someone with years of experience using a potter's wheel. Machinery had replaced Heerich at the flower pot factory where he had worked, and he now made his living as a janitor at Detroit's train depot. Perry Stratton found him there, mop slung over his shoulder. She and Caulkins offered him pottery work in the evenings, so he could keep his day job. He accepted.

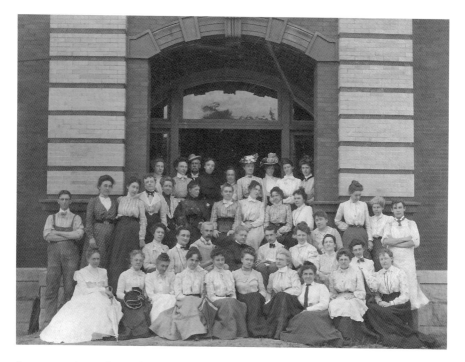

Summer students, along with faculty, including Charles F. Binns (*second row, third from left*), from the summer 1901 class of the New York State School of Clay-Working. Although not identified, Perry is believed to be one of these students. *Courtesy of College Archives, New York State College of Ceramics at Alfred University.*

Heerich was only a boy when he started in ceramics as an apprentice in a potter's shop in his native Alsace-Lorraine and had his own small pottery before coming to the United States in his late twenties, arriving in Detroit around 1902. Perry Stratton wrote in her autobiography that having the talented Heerich on staff made the pottery seem much more real:

> *In comparison with his sure movements, our amateur efforts now seemed artificial and of a kindergarten order. We felt quite well equipped when we watched him center a lump of clay on the spinning disk, working the treadle with his foot. Thrusting his two thumbs into the clay, he would hold the outside wall with palms and fingers, forcing the clay to rise with a cylindrical form. Then with a little patting and coaxing, a real shape with contours and curves was before our eyes. It was a very proud moment when Heerich cut through the bottom with a wire and lifted off our first thrown piece.*

From that point on, she devised a system where she sketched shapes on paper and pinned them to the wall near Heerich's wheel for him to find when he came in each evening. Heerich would then throw Perry Stratton's designs. By the time she returned the following day, the pieces would be firm enough that she could trim them yet soft enough that she could still affix a decoration if the design called for one.

Within roughly two years, the pottery became busier, and so Heerich gladly left his depot job to work full time for Perry Stratton and Caulkins. Perry Stratton could now focus on perfecting the glaze formulae. Like many potters and potteries at that time, she simultaneously worked to find her style and understand what the buying public wanted. After the 1900 Paris Exposition, consumers demanded the dull matte green crackle glaze made popular by Grueby. Perry wasn't the first potter to find inspiration in what came to be nicknamed "Grueby green." Whether it was Perry Stratton, Rookwood or any other pottery, no one could lay blame on anyone for providing the low-luster green people clamored to get.

As Perry Stratton continued to expand her knowledge base and understanding of chemicals and their varying glaze effects, she received an order to produce a large quantity of cold cream containers for Detroit pharmaceuticals business Frederick Stearns & Company. Because it called for four-sided jars, Heerich could not throw them on his potter's wheel. Perry Stratton spent a year working on making the little cosmetic jars— plus the necessary fitted lid—but could not consistently replicate the jar for them to be uniform. She eventually abandoned the effort.

Perry Stratton concealed any disillusionment she may have felt, believing that failures bring greater understanding. Determined to ensure the new pottery's success, she continued to pursue all she could about the medium. On a visit to Boston, she stopped in at Boston Public Library, where she read about a museum's vase that had started as a bright white porcelain before being buried for a thousand years, causing it to become crackled with "certain iron rust smears and an egg-shell texture," she wrote. She admired the results but not the time burden. She was anxious to re-create it:

> I could hardly wait until I reached home and could carry out the process as indicated. As usual, Mr. Caulkins, with his earnest sympathy, watched the preparations with quiet approval. He never hindered my exuberant enthusiasm no matter how far from the point they seemed to stray. So now, in our eagerness to witness the result as detailed by recognized authority, we did not wait long enough for the moisture to be completely dried out in

our example. The result was that after having been subjected to the highest heat we had ever developed, when we removed it from the muffle, a sizable piece had exploded from the top edge. Then came a surprise. Instead of the gleaming white it was supposed to have had, it showed a complete crackle, iron-rust smears and the eggshell texture. All the characteristics were reproduced according to the book, without waiting to be buried a thousand years. So much for theories from a litterateur and not a practical potter.

Dampering the kiln had caused the copper oxide in the glaze to become "a rich red wine color."

Through such research about the effects of different chemicals in glazes, Perry Stratton found that the mineral oxides prepared by chemical manufacturers were too fine, most likely because of the modern machinery that ground the minerals. The resulting glazes could not accomplish the desired earthy, naturalistic appearance she had sought. Soon Perry Stratton realized that a more primitive process with less finely ground oxides could accomplish the varied surface she desired—a perfect imperfection. She accomplished it by adding manganese, cobalt or iron oxide or "whatever one's imagination or instinct" might be, she wrote.

The partnership between Caulkins and Perry Stratton allowed their individual talents and abilities to shine. Perry Stratton was the artist and the chemist. Caulkins's skills were the business matters and everything relating to the kiln, including the arduous work of stacking the clay pieces within it, a job that wasn't too difficult with unfired clay pieces that could touch one another still—a bisque firing, because it resembles a biscuit—but a greater challenge with later firings of already glazed and fired products that cannot.

In 1903, Perry Stratton fashioned "a few clumsily made bowls and jars glazed with a dark green mat (the only color we had)," to take to Frank Burley of ceramics sales house Burley & Company in Chicago, she wrote in a 1946 journal article. The two were already well acquainted because Burley supplied Perry Stratton her unfinished china painting pieces for when she led classes and demonstrations. He liked what he saw of her new work and asked the studio to make bowls, lamp jars and whatever else they like for him to sell.

"I came home with my feet off the ground and an order for one thousand dollars' worth of 'whatever we could make,'" Perry Stratton continued. It was the pottery's first sizable successful commission. "A carte blanche order to bring in real money! A thousand dollars—a thousand dollars! It rang in my

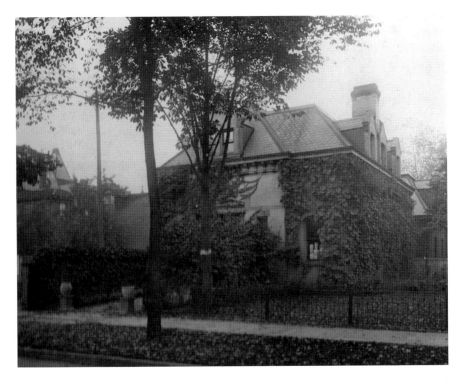

The "Stable Studio," the carriage house behind the Ransom Gillis House that Caulkins and Perry rented for their fledgling pottery, circa 1903. *Courtesy of Pewabic Pottery.*

ears all the way back to Detroit on the train. I could hardly wait to tell Mr. Caulkins of my success," she recounted in her memoirs.

Burley also suggested that the pottery needed a consistent trade name. Until then, pieces casually carried the name Revelation Pottery or Stable Pottery or sometimes simply hand-signed "Perry" or "MCP" in ink or glaze. Together the partners rattled off names, hoping something might stick as worthy and appropriate to represent their work. Perry Stratton wrote how she pulled together a list that included "Valor" and "Starbright" plus geographic names including Hamtramck and Orion, as well as the name Pewabic. Burley "pounced upon Pewabic, declaring that being an Indian word, it was purely American and we couldn't have too much of that," Perry Stratton wrote.

For Perry Stratton, Pewabic (pronounced *puh*-wah-bic) was a direct thread to her Hancock birthplace, home of the Pewabic copper mine. Although she had no reason to use it since her childhood, Perry Stratton often remembered the name fondly as an area where she and her father

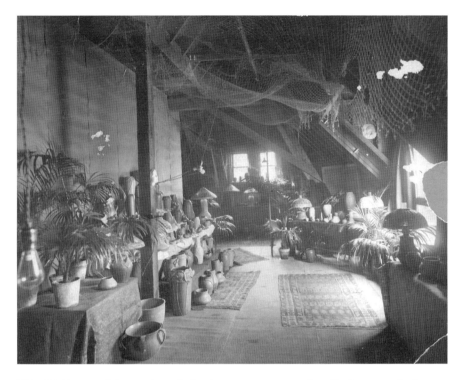

This 1903 image of the coachman's sleeping apartment turned studio showroom in the "Stable Studio" ran in the February 1905 issue of *Keramic Studio. Courtesy of Pewabic Pottery.*

took walks together when he was free from his demanding days. She liked the sound of the word, and in 1903, it became the name of the pottery.

In her memoirs, Perry Stratton recounted how two friends traced the word's meaning—just in case, they said, it had any negative connotations, beyond the *Pewabic* freighter that sank in Lake Huron in August 1865, carrying copper, hematite and fish from the Keweenaw Peninsula. Her friends announced that the word meant "clay with a copper color," a meaning that seemed "foreordained" to Perry Stratton, who related the information often. However, that meaning appears to be inaccurate. The word *pewabic* more likely originates from the Ojibway word *biwabik*, meaning iron or metal. *Miskwabik* or *osawabik* are closer to the word copper and *wabigun* or *wababik* closer to the translation of clay.

Although the name remained the same throughout Pewabic's history, the pottery's mark—impressed into the bottom of the clay or ink-stamped onto a paper label—changed over time, a move that helps experts date pieces. The first mark for Pewabic came in a circular shape with the word spelled

out above Detroit. The circle mark evolved into one where a large *P* loomed over a smaller *p* in the center. Later yet came the word *Pewabic* with maple leaves and a paper label with a triangular "Pewabic Pottery Detroit." Others followed, as marks change to denote artists and eras.

Perry Stratton and her co-workers at the newly named pottery began to fill Burley's commission. As in the past, she sketched the shapes for Heerich to throw on the wheel and the next day decorated the pieces with flowers, leaves, peacocks or other accents, designs or flourishes.

That first order for Burley & Company consisted of 132 pieces that totaled $1,068.10. With payment received on October 8, 1903, Burley became the first official entry in Pewabic's books, and obvious cause for celebration: "Mr. Caulkins, Heerich, Julius and I danced about the room. As I remember it, almost every one in Detroit knew about it and congratulated us," she wrote.

Perry Stratton was proud of the work they did for Burley yet noticed that it seemed more commercial than artistic, negating an important part of her vision for the pottery. But for now, it was still time to celebrate and to take orders that started to pour in. The pottery added bowls and pots to its product list, mostly in varying shades of green, depending on the amount of copper oxide Perry Stratton used in the glaze. She was eager to branch out with other colors and continuously experimented. With any failures, she resolutely decided that "mourning would not do" and tried again, always determined to learn from mistakes. Caulkins added another kiln that would better suit the pottery, as orders for large lamp bases quickly dominated their business and quickly filled the kilns to capacity. In the late afternoons and some evenings, Caulkins would be on hand to keep a watchful eye on a firing kiln, often alternating with Perry Stratton, each taking individual breaks for meals.

"By going 50 feet down the alley, we could go through a gate into the Caulkins garden so that he could slip home. We frequently 'took turns' watching the kiln, going over to the house one at a time for meals. So I too was washed and fed. Surely the latter was true, day in and day out," she noted, adding how the Caulkins family warmly included her into their largish fold. "I was made to feel a part of them."

Perry Stratton used every opportunity to grow and improve. When a neighbor she considered charming yet "high-brow" called one morning to invite her to see a lamp she recently purchased, Perry Stratton hated to leave her work but obliged, always willing to learn. The self-proclaimed "very difficult to please" woman informed Perry Stratton that she had looked far

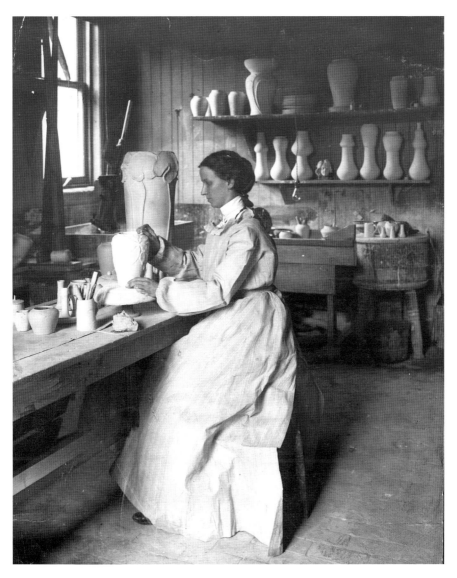

Mary Chase Perry decorates a vase at the "Stable Studio," from the February 1905 *Keramic Studio. Courtesy of Pewabic Pottery.*

and wide—including on trips to New York and Chicago—before choosing what she considered to be of "the highest order." The neighbor exalted the piece's virtues, as well as the great service she warmly provided by letting Perry Stratton learn from it. When she finally did set her eyes on the lamp, Perry Stratton's heart jumped, describing the moment in her autobiography:

> *I could truthfully assure her with all meekness that I had already learned more from it than she could ever imagine, for it was none other than my fateful cat-tailed lotus-leaved lamp base: which had been topped by a gorgeous, leaded glass shade. My dear old partner chuckled and paraphrased "Cat-tail comes home to roost."*

Such victories reassured and inspired Perry Stratton to keep giving the pottery her all. Making progress was in the forefront of her mind, yet as she worked to branch out into other colors, she began to notice how the green glaze pieces received preferential treatment from her partner during kiln loading. She took the opportunity to devise a playful plan to make it more challenging for Caulkins to show his favoritism, noting the account in her memoirs:

> *Something had to be done about it—and without words. The green vases were a light grey after being glazed and before being fired. The new pieces were a reddish brown like iron-rust from iron oxide in the glaze, so it was easy to tell them apart and discredit the reddish ones. By adding a minimum of iron to the green glazes, I discovered the color was not affected, and the two glazes before they were fired were so similar that they would not be told apart. In this way Mr. Caulkins would not tell which was which. I shamelessly stained both glazes red. From that time they received equally good treatment at his hands. It was about the only deception I ever played on him, and later he gave full admission that my steps had been justified in view of the fact that our next order from Burley's was more than one-half for "buff and brown."*

When Pewabic exhibited buff, yellow and brown mat glazes after the 1904 St. Louis Exposition, sales increased, as did Perry Stratton's recognition as a potter. A 1905 *Keramic Studio* article noted that the former china painter's "simple shapes and quiet color" stood out from the others, and that Perry Stratton's new glaze colors were "a relief from the eternal mat greens with which every would-be pottery is trying to outdistance Grueby and win fame and fortune before the fad is past."

The article also commended Perry Stratton's hardworking crew: "With only three helpers," describing the jobs of Caulkins, Heerich and Albus, "she has turned out not only an astonishing amount of work but many pieces of unusual artistic merit which will assuredly bring her merited success in a financial way."

With successes and milestones now under their belts, Caulkins and Perry Stratton decided that it was time to consider graduating from the Stable Studio to a larger space fully dedicated at inception to Pewabic Pottery.

A NEW MOVEMENT, A NEW BUILDING
AND A NEW OUTLOOK

"Every moment there was something to be done."

Like England and Europe had during the second half of the nineteenth century, America began to experience a resurgence in the traditional craftsmanship celebrated by the Arts and Crafts movement. Detroit was no different. In 1906, newspaperman George Gough Booth called together like-minded artisans and art enthusiasts to his *Detroit News* office to form the Detroit Society of Arts and Crafts. Using the model of the 1897-established Boston Society of Arts and Crafts, the DSAC worked to encourage an appreciation of handicrafts by better connecting consumer and producer and to educate while eschewing the industrialization and mass production that had become increasingly widespread.

At its inception, the group counted 112 members, including Pewabic's founders, with Booth serving as its first president and W.B. Stratton as vice-president. The group quickly became instrumental in promoting handcrafted art, enabling Pewabic's founders, as well as others, to more easily share their artistic and commercial vision. Perry Stratton called the DSAC "a cementing together of those who were stirred by cultural movements in the world":

Detroit enjoyed a heyday of artistic illumination—our foremost citizens were active members of the organization and "the Board" was noted for an almost never failing full attendance at its progressive and vital meetings. Naturally, the Society and Pewabic Pottery benefitted mutually from these

contacts. Through the National Federation of Arts, our vases were shown at centers throughout the country.

The influence the DSAC provided became apparent to Perry Stratton, who now had her sights on Pewabic venturing into a wider field beyond bowls, vases and lamps. She showed Stratton a three- by six-inch tile she made, with "rounded edges and slightly uneven surface," she described. He suggested that such tiles would work in a client's house. With that successful effort, and the DSAC giving the potential new product much-needed feet to carry it forward, she decided that making architectural tiles was the right design direction for Pewabic.

Caulkins trusted her instincts, and again Perry Stratton set out to educate herself and to better understand what tile-making on a larger scale would entail. She visited American Encaustic Tiling Company in Zanesville, Ohio, considered one of the largest tile companies at that time. In her autobiography, Perry Stratton described how the plant manager met her with skepticism:

> *I found myself in his office one spring morning. His eyebrows went up and he looked down at me condescendingly when I voiced my desire to know how to make a tile. Me—an insignificant young person—at the door of a million dollar corporation—a tremendous plant, with flying wheels, and flying feet, and dust in the air. When he asked how it would be possible to manufacture tile without all the equipment surrounding us, my ardor was not dampened. I knew that I could make one tile of a sort by hand. If I could make one, then I might make ten, and if I make ten, then I might make enough for a fireplace—which is the very thing that came to pass.*

A reinvented Perry Stratton set forth as a tile maker. She ordered the equipment American Encaustic told her she'd need, including a dust press and assorted shaped molds. Armed with her new experience, and the *Handbook of Ornament* by Franz S. Meyer, Perry Stratton carefully ushered in Pewabic's new purpose and adventure. "When we showed our architect properly pressed, straight-edged and smoothed surfaced examples, he exclaimed 'Why! I wanted your handmade effect!' So the mechanical molds were never used," she wrote in the *Bulletin of the American Ceramic Society* in 1946.

It soon became obvious that her only use for the steel factory molds was to demonstrate to architects the difference between tiles constructed

mechanically and Pewabic's characteristically handcrafted non-uniform tiles with rounded edges. Other architects also came to Pewabic expressly because they preferred that tile over a more precise and exact one.

Tile production brought a certain practicality to Pewabic that Perry Stratton admired. Soon, commercial tile orders began, with the Griswold Hotel in Detroit being one of the first. Owner Fred Postal approached Pewabic to redo the hotel's bar using its new tiles. During the firing process, something went askew, leaving glaze cracks and other surface imperfections on much of the Griswold's green-blue tiles' terra-cotta facing. Perry Stratton suspected that the combination of a blazing hot summer day and the kiln's unforgiving heat fired the tiles too rapidly, creating the flaws. Whatever the reason, the results and the delay they would cause devastated Perry Stratton. "If I appeared as minute as I felt, it would have taken a microscope to discover me," she wrote, recalling the dread she felt at having to explain to Postal the holdup they now faced.

Reading the disappointment on her face, Postal said that he hadn't before felt so sorry for anyone, knowing all the work she had put into the project. He carefully examining the damaged tiles and announced that he found their imperfections "friendlier" than brand-new tiles would be and better suited for the space. He wanted those very tiles installed as they were. "And he proved to be perfectly right," Perry Stratton wrote. "We were so anxious to deliver material perfect mechanically, that we had utterly failed to recognize a more important factor, a quality which Mr. Postal either foresaw, or out of the goodness of his heart pretended he saw. I thought he was an angel just the same."

The installation went on as planned, and not only Postal but also Caulkins admired the finished product. Postal so loved Pewabic's work that more than once when he spotted Perry Stratton walking by on the street, he excitedly called her inside to introduce customers to the person who produced the tile work. She resisted pointing out "that one of the most conspicuous plaques was an ecclesiastic symbol, turned upside down," which she had selected from church installation tiles because she thought it made a nice design.

Soon, architectural orders quickly filed into the pottery, with architects beginning to incorporate Pewabic tiles into their residential and commercial plans. According to Perry Stratton, the new direction pleased Caulkins, whom she said saw it as more dignified and businesslike than anything to date for the young pottery. "Up to this time he had been fairly reticent, not to say negative in acknowledging his really active connection with our 'little shebang,' as he termed the barn pottery," wrote Perry Stratton.

From then on, Caulkins comfortably and even eagerly enjoyed being recognized as a co-owner of the pottery, which was quickly outgrowing the Stable Studio. The pair knew that increased demand and production meant space was only going to become even less manageable, especially storing installations and finished pieces pre-delivery. They began to look for a vacant lot within Detroit on which to construct a building. Perry Stratton was proud to reach such a milestone, especially for Caulkins, noting the hard work, time and money he contributed. To her, the building wasn't so much an investment as a fulfillment of an ideal that confirmed the art they made was worthy.

Soon the pair selected a three-hundred-foot-deep lot on East Jefferson Avenue, about a mile and a half east of Belle Isle, directly across from Water Works Park. They liked the view of the park with the Detroit River just beyond it. Most importantly, they liked that the location lacked zoning restrictions that might prevent them from running a fully functioning pottery, complete with a smokestack for its kilns. They opted to place the building far back on the property, allowing for an expansive and inviting front lawn that would stretch to Jefferson. For Perry Stratton, this move toward permanence spoke volumes and was further validation:

> I wish I could define just what the new building stood for. The nearest I can express is that it was the fulfillment of an ideal, justified by the material success of finding a market for our productions. On this ground, at the moment, I could not help feeling a warm satisfaction over what we had been able to accomplish.

For the building plans, the business partners consulted their architect friend W.B. Stratton of Stratton and Baldwin. They shared all that they knew they wanted in the building and admitted that their greenness in the business prevented them from being able to predict with any certainty their future needs.

Because Caulkins was of English descent and "had a strong predilection for the architecture of his forefathers," the threesome opted for a Tudor-style exterior with a medium-hip roof that more closely resembled an English inn than a manufacturing plant. In 1907, the building—and Perry Stratton's dreams—came to life, as she noted in her autobiography:

> Whether suitable or not for a manufacturing place or whether consistent with the purpose in mind, we settled upon an exterior which had its precedent

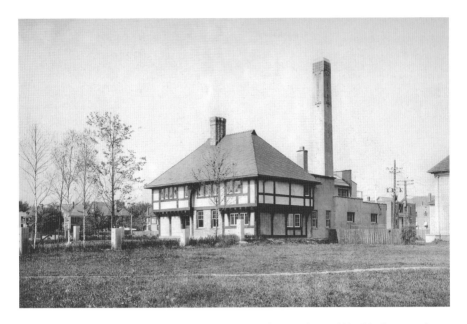

The new pottery building as visible from Hurlburt Street, circa 1907–12. *Courtesy of Pewabic Pottery.*

in an old English Inn from the Kent district. It was a long, low, and rambling, of brick in the lower part with stucco and beams in the second story. This formed the first section which led into a high two-story room, where our kilns were to be. This part was suitably of brick, inside and out, and looked strong and fire-proof as it really was. The outside walls had brick buttresses which made it seem like a fortress, with windows high up, swinging outward.

With the other interior spaces—a long narrow glaze room to house the glaze mills and grinding wheels; a smaller room for Heerich's throwing wheel; and offices, exhibition space and studios upstairs—the building accommodated almost everything the pottery needed to run sufficiently. While it included design space for Perry Stratton, she later wrote that her studio "turned out to be every part of the building from cellar to roof."

As the interior neared completion, Heerich and Albus made tiles to incorporate into the building's mantel, the deep window sills and various floors, some of which remain today. Because the building was a pottery from its inception, one architectural element stood far and above the most monumental: the kiln chimney. Stratton designed a tall and sturdy

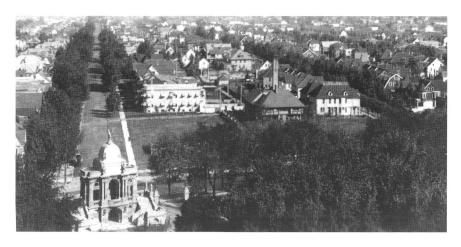

An aerial photograph of Pewabic Pottery's new building, circa 1907–12. *Courtesy of Pewabic Pottery.*

yet picturesque chimney stack that reached roughly forty feet beyond the building's roof, with Pewabic tile incorporated into it proudly pronouncing the structure's purpose. This chimney was not "a mere factory stack with its flag of common toil rising into the air," described Perry Stratton. No. From this "were to rise vapors from the sculptured forms in the kilns below."

"It was more wonderful than it is possible to express in words, to be able to have all this equipment and machinery, which would allow us to carry out so much more work, and, we hoped, better work," Perry Stratton wrote about the new space. She couldn't conceal her excitement about the new building and how it enhanced Pewabic's ability to succeed. With it came an arduous responsibility set squarely on her shoulders, adding to an apprehension that always lingered that she might disappoint her most ardent supporter, Caulkins. Fortunately, Pewabic was too busy for it to consume her. "Every moment there was something to be done," she wrote about the early days on East Jefferson.

The design and construction processes also brought the ceramicist and architect Stratton closer. By then he had become a calming influence to the petite ceramicist, reassuring her that her dedication to the pottery—to which she now felt even more tied, she wrote—was well placed. Whenever she nervously wondered if it was worth it, Stratton could relate and empathize, having similarly established himself in his own calling.

"I found myself dependent on his point of view in many ways," she wrote about working closely with Stratton. "He appreciated and understood the

position in which I had placed myself, almost mortgaging my future to the development of the Pottery."

Born in Ithaca, New York, in 1864, William Buck Stratton opened the Detroit architectural firm of Stratton and Baldwin with Frank Baldwin in 1890, designing commercial and residential structures throughout the city, most notably in the Indian Village neighborhood, not far from Pewabic.

With the new building complete, friends and Pewabic supporters came together to celebrate its opening, including art collector Freer and Arthur Dow, design instructor at Teacher's College at Columbia University. Perry Stratton had become well acquainted with Dow through Freer and was honored when Dow inquired if Pewabic could make place settings for Columbia's new Household Arts department dining room. Place settings was new territory for Pewabic, but Perry Stratton wasn't one to shirk at expanding Pewabic's—or her own—horizons and certainly wouldn't start now with the weight of the new building on her shoulders. "At the moment, I would have accepted an order for hob-nailed boots," she wrote about the commission for plates, cups and saucers, plus a variety of other serving ware.

While making tableware didn't resonate with Perry Stratton as the most inviting artistic opportunity, working with Dow did. He wasn't simply asking for her to make new dishes. He was looking to Pewabic to create ceramic pieces that would act as exemplary models for his students. To accomplish that, Dow envisioned a design that featured a buff-colored body broken by a crackled glaze and straight lines of varying widths plus a broad gray-green band around the rim, parallel to a wavy yellow line.

Perry Stratton called the colors' effects on paper "soft and charming." Translating it into pottery proved to be a greater challenge. She later said of Dow that he knew design but "little about ceramic bodies." When the colors initially appeared dull, Perry Stratton reconsidered her processes and decided to apply a transparent glaze before firing the pieces again. Only then did the intended brightness appear. Pewabic made sixty dozen plates, cups and saucers for Dow. "By this time, Mr. Caulkins was as proud as a peacock, and brought in all the neighbors to see our 'china shop,' as he called it, filled with the finished ware and we were gratified (to state it mildly) when Professor Dow expressed his approval," she explained.

Years later, when two of Dow's former students visited Pewabic, Perry Stratton learned that the plates' wavy line represented the Hudson River and the green band the Palisades, a line of steep cliffs along the lower Hudson River's west side in northeastern New Jersey and southern New York. Perry Stratton knew nothing of the intended symbolism when she

Pewabic Pottery's museum and gallery space in the second story of the new building, circa 1907–8. *Courtesy of Pewabic Pottery.*

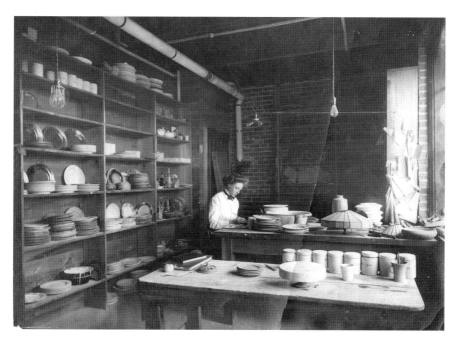

Mary Chase Perry at work in the pottery, 1910. *Courtesy of Pewabic Pottery.*

created the pieces and appreciated learning their significance, and how such details reflected Dow.

She found similarly rewarding and meaningful moments and adventures (some more welcome than others) at various times in the new pottery building and at least one event that might have persuaded less dedicated people to switch professions. In her memoirs, she recounted a night when she was alone in the two-and-a-half-story kiln room "with shadows lurking around the base and windows, the sky-light above, two kilns roaring and now and then a sputter of burning oil." As they are prone to do, the kiln burner occasionally sent an overflow spill out onto its fireproof surroundings. Whenever that happened, whomever was watching the kiln would use a poker to dislodge whatever carbon formation may be blocking the combustion chamber, an action that produced a "shower of sparks" that "appeared infernal to the uninitiated." Perry Stratton did just that. Before long, she noticed that her legs felt unusually warm. Her woolen skirt had caught fire.

"As I looked down, a little ring of flames curled up all around the bottom of the skirt. It took thinking and quicker action," recalled Perry Stratton, who rushed into a nearby tub of water. Catastrophe averted, afterward Perry casually noted that "some extraordinarily nice things" came out of the kiln the following day.

For Perry Stratton, the building's kerosene-soaked air, thick from a kiln's quick firing, was something to savor, and any danger that came with it was par for the course. She recorded in her memoirs how it felt like home:

> *I sniffed the polluted air with positive joy. The noise of the oil burners purring along—sometimes sputtering and every now and then bursting upon the air like a pistol shot—the rolling of the jar mills with the sound of pebbles falling from the top to the bottom—the whirr of belts on squeaky pulleys, the stamping of the tile press with its thud-thud all combined to make a well-loved symphony to my accustomed ears. If every man and woman could feel so about his job!*

Perry Stratton loved her work. And now, with more architectural commissions keeping Pewabic busy, Perry Stratton saw an opportunity to make another business decision that would help Pewabic even more clearly define its style and set itself apart from others. "When our American buyers are able to see that domestic manufacture ought to fill both utility and aesthetic needs more fully than objects with a foreign stamp, it is possible

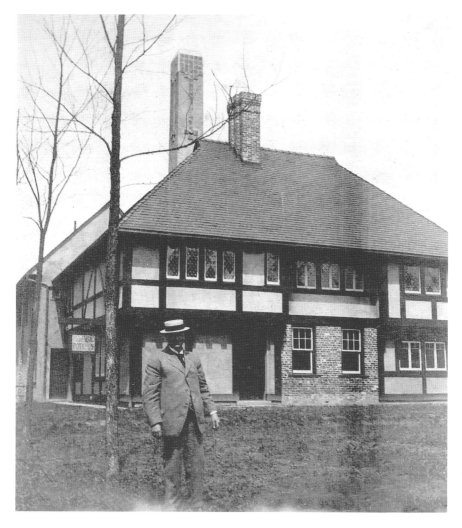

Horace Caulkins stands outside the pottery he founded with Mary Chase Perry, 1916. *Courtesy of Pewabic Pottery.*

that the public might be led to prefer them," wrote Perry Stratton, ahead of her time.

Now Perry Stratton believed it was time to resist imitating imported designs and homeware, notably the popular and in-demand but unrewarding lamp bases that Pewabic modeled after imports. She hoped that the growth since the pottery's relocation and the addition of architectural tiles opened the door to giving up such products once and for all, if for no other reason than that they didn't adequately reflect Pewabic, she said.

The pottery should express its artistic taste above and beyond all else, she wrote, otherwise the adventure that is Pewabic would be one without genuine pleasure and satisfaction. A sound return was vital to any business, including theirs, she said, but not at the cost of disliking the journey. As he had in the past, Caulkins respected Perry Stratton's intuition, acknowledging the validity of artistic growth within business. Trading immediate prosperity for long-term happiness and continued success was a gamble the two partners agreed was worth taking. "Mr. Caulkins was always open-minded, when we came to a semi-colon, not to say a period, in our progress," she wrote. "In fact he was almost psychic in his understanding of cause and effect."

Believing that Perry Stratton knew best, Caulkins was willing to risk their commercial success, including that some great unknown in Pewabic's future would "flower into something."

For three months, Perry Stratton and her small team of employees conceived of and constructed new designs, many of which were simpler in nature than earlier designs and free of decoration. New pieces seemed likely born as a result of Perry Stratton learning from Freer, as new pieces

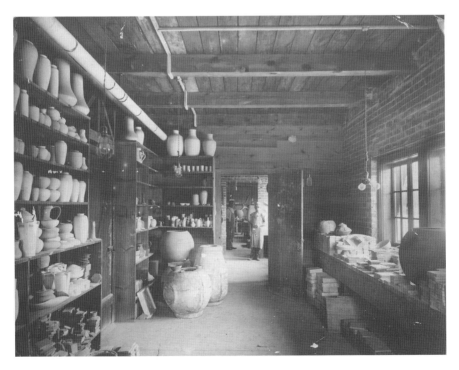

Joseph Heerich stands in the doorway of the production studio at Pewabic Pottery, 1910. *Courtesy of Pewabic Pottery.*

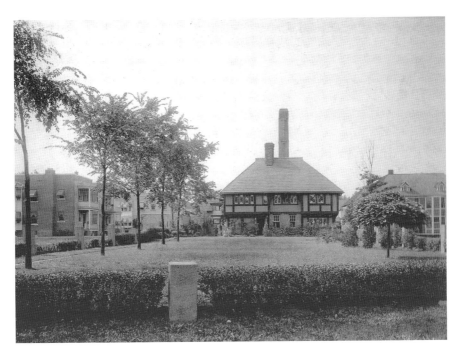

Pewabic Pottery, with its long, expansive lawn that stretched to Jefferson Avenue, circa 1912. *Courtesy of Pewabic Pottery.*

somewhat reflected an appreciation and influence of Asian art styles prevalent in his art collection. Pewabic's previously popular leaf forms also had had their day, Perry Stratton wrote, and she described Heerich's wheel as working at his bidding. Sometimes she would compliment him on his immediate understanding of her concepts, to which he'd chuckle, telling her, "It was the wheel did it."

By 1913, Pewabic had discontinued its lamps. Even with the extra work required to establish a new footing, Perry Stratton felt that her decision to change direction solidified Pewabic as what she always intended it to be: more of a laboratory studio driven by art rather than an industrial manufacturing plant solely focused on production numbers, echoing some the mission of the Detroit Society of Arts and Crafts.

The DSAC was growing too. In 1911, the group opened a gallery to sell art, including works by artists outside the area, like ceramicists Robineau and Binns, whose work newspaperman George Booth happened to collect. In 1916, architects Maxwell Grylls of Smith, Hinchman and Grylls and W.B. Stratton, both DSAC members, designed an Arts and Crafts–style wood-

and-stucco building that would rise up on property donated by Booth at 47 Watson Street near Woodward Avenue, making Detroit the first such society to have its own independent building, with galleries, studios, a courtyard, an auditorium and an education space.

Ultimately, it was the Arts and Crafts movement that steered Perry Stratton in the direction of designing architectural tiles, shaping Pewabic's future and very likely the largest part of its success. Growing commissions for installations meant that Pewabic had to grow too. Louis Tomasi, an Italian-born Austrian-trained potter, started at Pewabic in 1910. John Graziosi followed his childhood friend Tomasi to the United States and to Pewabic, with Perry Stratton herself picking him up when he arrived at the train station. Heerich's nephew, Joseph Ender, appeared on the scene straight from Germany in 1911 and immediately went to work. Ender hailed from the same town and trained at the same place Heerich had, so seemed a natural fit. In Pewabic's early years, the team of Albus, Ender, Tomasi and Graziosi accomplished the commissions, as Perry Stratton noted in her autobiography: "Although we do not pretend to have specialists and prefer to have all our men know the various types of work necessary at the Pottery, they do get into individual jobs out of habit, and so Joe was soon stacking the kilns putting clay in the blunger, grinding the grog and attending the glaze mills."

Work continued to build, including a 1912 commission from the Detroit Shipbuilding Company to furnish and install tile on the floor, bar and cove base of the buffet in a side-wheeler steamboat called the *City of Detroit III*. The added work and workforce meant a need to expand the building in 1912 to accommodate serious clay-making equipment, beyond the small "Crossley clay outfit" they had installed in the building's basement. The new space included a full-size blunger, filter press and pug mill, as well as greater room for tile pressing and glazing and another second-story space for laying out installations, education and storage. Perry Stratton plainly told the *Detroit Mirror*, "We did what was to be done as it came along."

Committed to the efforts of the DSAC, she even took the opportunity to publicly announce her engagement to W.B. Stratton during one of the club's events when it hosted the 1918 American Federation of Arts convention. Both in their fifties, after decades of friendship, the pair married at the home of Horace and Minnie Caulkins on June 19, 1918.

The next year, with women's organizations growing throughout the country, Detroit women launched efforts to build a meeting place. With Stratton as architect, the newlyweds collaborated on the strongly Arts and

Storage at Pewabic shows the outstretched dove that was an extra, in case one were to be damaged during firing, in transit or installation, circa 1922–24. It now hangs in Pewabic's second-floor gallery space. *Courtesy of Pewabic Pottery.*

Crafts–influenced structure that featured many Pewabic tile elements, notably in the building's arched entryway, a stairwell and drinking fountains. Located at 2110 Park Avenue in downtown Detroit, the Women's City Club opened in 1924.

Perry Stratton, who served as the club's first vice-president, even packed up the club's plain white dishware and took it to Pewabic to reglaze it in more appealing club colors: a warm yellow, a delicate green and a gray that became known as the Pewabic color "City Club grey."

As for the DSAC, its leaders decided to focus their efforts on building a dedicated art school. The early school board read like a who's who of the Detroit art scene, including Perry Stratton, Booth, Albert Kahn and Grylls. In 1926, some 280 students enrolled in the first year of the Art School of the Detroit Society of Arts and Crafts, dedicated to the training of art and design. Eventually, the school persuaded auto manufacturers of the need in have in-house design studios, and the school uniquely tailored programs to provide designers to operate such studios.

"Today you know Arts and Crafts as a school. But our purpose in founding it was to promote beautiful objects for everyday use. Few people knew or cared about handcrafted pottery, metal or textiles in those days. The public thought art had to be in a frame or on a pedestal," a 1957 *Detroit News* article quoted Perry Stratton as saying.

When the new school buildings went up, the old Watson Street building emptied and eventually fell into disrepair. The school went on to become known as the Center for Creative Studies and eventually the College for Creative Studies. Abandoned and severely damaged by time, neglect and a fire, the city razed the Watson Street building in 2006 to make way for parking.

THE GLAZES

"Painting with fire."

Pewabic's move into architectural tiles gave Perry Stratton added incentive and opportunity to throw herself into what would become her greatest professional and artistic passion: creating glazes. She experimented tirelessly, eager to make strides and breakthroughs. In her memoirs, Perry Stratton described her career as one that required stamina and the ability to "withstand inevitable disappointments," as well as to have an understanding of the nature of gambling—or, in her case, gambling with nature. "We were ready to try anything, no matter how foolish it seemed at the outset—and of course having few technical inhibitions, we did carry out many absurdities. But out of them all came wisps of interest—little whimsies in the way of color or texture."

Conditions were not always easy. "Of course, the room became black and the air was not pleasant to breathe, also it would have been a challenge to one's beauty if one had any," wrote Perry Stratton playfully, adding that the only thing she and Caulkins were particular about was rubbing hands across their faces, leaving tell-tale streaks of their efforts. "Otherwise we were Othelloish in aspect after a lovely seven-hour session with our new pet."

Perry Stratton took care to record what worked and what did not, sometimes altering copper content, the amounts of chemicals and colorants, temperatures and even the atmosphere—the air—allowed in the kiln that would change the reaction of all the factors. With each effort, Perry Stratton

learned. Through education and experimentation, she determined that glazes containing copper—even in "modicum" amounts for the pale green—created a multitude of effects, dependent on kiln temperature and firing time. "Aside from 'playing with fire,' it pleases me to think of it as painting with fire," wrote Perry Stratton, crediting her harnessed "amateur spirit" for her determination to continually evolve glazes and thereby possibly justify Pewabic's existence:

> *It had never been our aim or intention to make things merely for commercial profit or only to add to the ceramic production that have been coming from kilns from the beginning of time. We hoped to accomplish this too, as the expense of our development must be met—but we measured a commercial success as a byproduct, anticipating or at least hoping with a deep hope that a real and hitherto-unmade type of ceramics would result. Whether this has been accomplished or not will have to be put to the test of the ages, with comparisons of all that has gone before and all that is to come.*

Perry Stratton always steadfastly marched toward improving every aspect of the business, but once plans began for a new commission, project or effort, it was her time to shine. In those times, Perry Stratton would retreat to her "trusty" formulae book to work toward finding the right mixture and ultimately glaze for each job, baking possibilities in a small test kiln to find the right combination of color and texture for each and ensuring that the finished products would consistently capture the anticipated shade. "With each new commission, my friendly book, adviser, counselor, thickens—and my table has more pans of colored glazes," she wrote.

As Pewabic matured, so did Perry Stratton's techniques. She developed and honed her glazes, becoming more and more familiar with the effects that different chemicals and combinations could trigger, further setting her apart from her contemporaries. As demand for architectural installations increased, Perry Stratton often combined a frit with Pewabic's matte glazes, producing what she considered "a happy combination" of flat color and a marbled, texture-rich look that, Perry Stratton wrote, "seemed to make a whole surface more vital and to give it a certain 'awakeness.'"

Even when Perry Stratton found what she was looking for, she often continued to evolve the glaze in an effort to soften a sharpness or hone or alter a quality to make its effects rarer still. And some believe she possibly put her best effort forward with variations of her favorite color, blue. She calculated how best to retain a rich blue matte glaze that could appear

PEWABIC POTTERY
2161 JEFFERSON AVE.
DETROIT
MICH.

MARY CHASE PERRY
H. J. CAULKINS

Nov. 24, 1907.

R. S. Roeschlaub,

Denver, Col.

Dear Sir:

We enclose a reproduction of our new building, which we hope will serve as an introduction to Pewabic Pottery.

We make tile of unglazed natural clay. We make tile with half-glaze or all bright glaze if desired. But we make tile particularly with dull glazes, which are at present in demand.

The special characteristic of Pewabic glaze is that it has depth and that quality of vibration, which keeps it from being a flat solid tone. The plain colors are ivory, browns, blues, greens and grey. We also present combinations of color, which have been most acceptably received, as ivory and brown, brown and green, robin's egg and blue, etc.

Aside from standard work, we are particularly desirous of furnishing specially executed tile of suggested color or from individual designs.

If you are interested in our work, we shall be pleased to send a few tile to you, or to enter into correspondence regarding fire-places or architectural work in connection with which tile or other ceramic ornament may be used.

Very truly yours,

Pewabic Pottery.

We will be pleased to know more about your product, and have some samples in our care. Yours Truly, Robert S. Roeschlaub

Horace Caulkins pens a letter to architect R.S. Roeschlaub about Pewabic's new building and the tiles the pottery company has to offer. *Courtesy of Pewabic Pottery.*

in different guises, even one with a mellow second translucent covering veiling its intensity, offering an opaline quality where the glaze ran thin in the kiln. Another glaze offered a golden sheen surface with deep, rich midnight shadings:

*Vases of this nature soon gained popularity, and possibly many people feel
that it is the most typical effect of Pewabic. Personally it has a strong
appeal to me when the surface is not too brilliant, and changing lights seem
to come and go, yet show a depth which the eye ever seeks to penetrate. Again
this same blue broke into a thousand refractions of violet, and made one
wonder whether it were not really purple, after all.*

Perry Stratton became well known for her Egyptian or Persian blue and even
for the blue dresses she frequently wore.

Colors captivated Perry Stratton. She loved the almost elusive intricacies
each glaze delivered—the unpredictable nature that could create a
unique appearance, even when something came out precisely as planned.
Although she could appreciate the clear tones of contemporary pieces
or the precision desired and demonstrated in ancient Chinese pottery,
straight immoveable colors that didn't react with the light rarely interested
her, especially when it came to Pewabic.

She didn't seek purity in her colors; rather, the opposite appealed to
her. She most desired the organic subtleties inherent in minerals. At one
point, she conducted a study of three extraordinary jar samples: one "a
scintillating sea-green jade" color made from "alternately oxidizing and
reducing atmosphere," another a deeper green bottom with "metallic
gold" on top and the third a completely covered "wine red." "The
amazing part is that all three jars were dipped in the same bowl of glaze,
one after the other," Perry Stratton wrote. "As I remember it, the glaze
was not even stirred between the dippings and the jars were placed side
by side in the kiln. They made striking examples, which were witness to
a definite 'playing with fire.'"

Visitors to the pottery "seldom failed to feel a spell of beauty from the
collection in the cases," Perry Stratton wrote. By this time, individuals,
ladies' groups and Scout troops would drop in to experience the pottery.
Perry Stratton would explain the potter's processes from clay-making
through to firing and how Pewabic worked. Clearly more comfortable
working in her lab than acting as a tour guide, Perry Stratton liked that
Caulkins enjoyed being the courteous host. She warmly recalled looking
on as Caulkins proudly showed visitors his favorite pieces. He called
attention to the way light caught a prism of colors at different angles. As
she watched, Perry Stratton felt a surge of gratitude that their venture was
a success, not only in the eyes of the community or experts but also in the
eyes of her esteemed business partner, Caulkins.

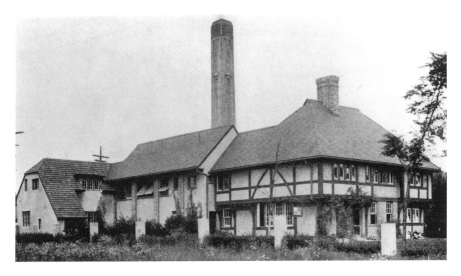

A view of Pewabic in 1916 shows the 1912 addition in the rear that holds the clay-making area and educational studio. *Courtesy of Pewabic Pottery.*

Perry Stratton frequently made efforts to encourage honest appreciation of art, without using cost as a measure. Before one group's visit, Caulkins and Perry Stratton decided to remove price tags from the vases with the hope that the women's group would judge each piece solely on aesthetics. "This experience brought it home to me that we're not yet on a plane of adjudicating spiritual values without knowledge of material worth," Perry Stratton wrote. "Many times I have seen this exemplified in the thermometer of admiration directed to one of Mr. Freer's bowls, which would rise to heights at his statement of $20,000 as its value in the museum market."

Freer frequented Pewabic to take notice of Perry Stratton's progress. She found his visits artistically stimulating and his approvals of her work the most rewarding. His art collection was incomparable, so voluminous and impressive that he designed his Detroit house to include connected galleries to accommodate his accumulation of art treasures. He was the greatest collector of the work of James McNeill Whistler, even purchasing the artist's famed *Harmony in Blue and Gold: The Peacock Room*, which Freer had dismantled and shipped from England to be rebuilt at his home in Detroit. A Pewabic benefactor, Freer kept a Pewabic "jar" held a spot of honor in the room. "He encouraged us from the start by purchasing and carrying off exuberantly, what he called 'top-notchers,' or 'hum-dingers,'" recalled Perry Stratton about Freer. "A particularly unusual example he would glorify as a 'He-One.'

Pewabic Pottery founders Horace J. Caulkins and Mary Chase Perry Stratton outside the pottery, circa 1920. *Courtesy of Pewabic Pottery.*

It made no difference how small the object, so long as he recognized a spark of fine quality in it."

Perry Stratton delighted in Freer's inquisitive nature. He would ask her motivations and trace her decision-making regarding designs and glaze selections. His art collection served as an example to Perry Stratton of the heights to which she could aim, and he challenged her to grow. She could

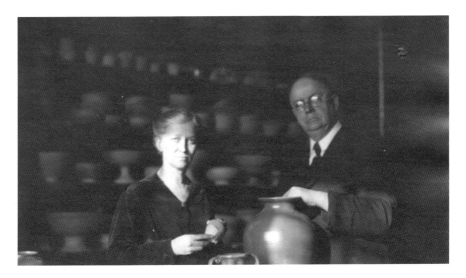

The business partners inside the pottery, circa 1920. *Courtesy of Pewabic Pottery.*

not resist rising to meet his challenges. He fueled her efforts at a time when other potteries that weren't evolving were disappearing.

As early as 1902, Freer told Perry Stratton that Pewabic would not be able to produce a ruby iridescence. "If we were not familiar with the method of production, the problem was all the more inviting," Perry Stratton once wrote. And sure enough, in probably 1906 Perry Stratton presented Freer with a red bowl with a tapering foot, what she called an "unmistakable example of copper reduction with rainbow lights." Freer's delight "knew no bounds." This piece may be one known as *First Iridescent 1906* that reportedly exists in private hands. Other accounts suggest that the first iridescent piece came several years later in 1909. In still another account, Jaqueline Peck wrote in *Detroit Women's City Club Magazine* in April 1952, "It was in 1910 that she first drew from a kiln a tiny bowl whose iridescent glaze glistened like frost—a glaze the likes of which had not been seen since the days of 14th century Spain."

Whenever established, some considered Perry Stratton's iridescent glaze identical to glazes found in fragments excavated in Raqqa, Syria. Others said it was equal to glazes from ancient Spain. Whatever it was, it was the reason people continuously quote Charles Freer, who apparently told a group of Detroit industrialists, "Hundreds of years from now the names on your motor cars and drug factories may be forgotten. But people will know that Pewabic pottery was made in Detroit because this beauty will live."

Freer was likely the impetus for Perry Stratton discovering Pewabic's six iridescent glaze colors—gold, rose, copper, yellow, purple and green—all built from the base of her own frit formula, to which she would add elements such as silver carbonate, zinc oxide, carbonate of copper, bismuth and a variety of other ingredients to consistently achieve her desired look. Perry Stratton unfailingly avoided imitating another material, such as wood. She wanted Pewabic glazes to be recognizable as Pewabic and a glaze.

Perry Stratton and Freer found great camaraderie in each other. Freer once told her about a noble Chinese general who before battle would call on his soldiers to bring "all their sources of fiery zeal," Perry Stratton recalled, while the general gathered his own strength from a small piece of jade he kept secured in his garment. Freer came to own that same jade piece. When he fell ill, knowing how much he loved the feel and texture of glaze, Perry Stratton gave Freer several glaze samples he could rub together in his pocket as he recuperated. Once well again, Freer returned the samples to Perry Stratton, who was grateful that her glazes provided him comfort and strength.

In Freer's final days, he asked Perry Stratton to send several recent pieces to his New York hotel room. She heard that Freer liked to keep the small jars at his bedside, periodically holding them in his hands.

"If anything that we accomplished proved to be a grain of consolation to the man who had done so much for us, our whole effort was justified," said Perry Stratton. She recounted that she had heard that another of Freer's friends, Louisine Havemeyer, art collector, philanthropist and suffragist, had visited him and inquired of the origin of a Han Chinese–like jar she noticed he had. Freer took great pleasure pointing out that the jar was not Han, but American. When asked if she could keep it for her own collection, Freer told her "eventually," but she reportedly took the little Pewabic jar anyway.

Later, when the H.O. Havemeyer Collection—named for Havemeyer's late husband—appeared on the art market, Emil Lorch, then dean of the University of Michigan School of Architecture, purchased a selection of items for the school, including a vase that reminded him of Pewabic, but that he believed might be Chinese. It was that same piece, Perry Stratton wrote, and "one time when he could secure all archeological data from the beginning." The piece remains part of the university's collection. Freer's unequaled art collection, including Pewabic pieces and Whistler's *Peacock Room*, landed elsewhere, at the Freer Gallery of Art at the Smithsonian in Washington, D.C.

"Naturally, Mr. Freer was greatly concerned over the final disposition of the marvelous collection of priceless objects which he had accumulated on

his many expeditions," Perry Stratton recalled. "We, in Detroit, hoped that our city might keep them. But we failed to meet requirements. Perhaps he felt that we were not mature enough in our civic art consciousness to know how to properly appreciate and maintain such a collection."

While the Detroit Institute of Arts did not get to house Freer's celebrated collection, the museum does have a number of Pewabic pieces donated by Freer, as well as by Perry Stratton, the Caulkins family and others.

THE INTRINSIC RELATIONSHIP BETWEEN
CRANBROOK AND PEWABIC

"Thistle and all."

The worlds of Cranbrook's George Gough Booth and Pewabic's Perry Stratton and Caulkins intersected like a basket weave through the early part of the twentieth century, and nowhere more so than the Detroit Society of Arts and Crafts. Each was instrumental in the founding and formative years of the DSAC, with their shared mission of marrying aesthetics with utilitarian handcraftsmanship, shunning industrialization and furthering handcrafted work and art in and around Detroit.

In 1904, Booth and his wife, Ellen Scripps Booth, purchased the roughly 175-acre Samuel Alexander Farm in Bloomfield Township. Booth spent the next three decades transforming the property into not only his home but also a carefully designed educational community, growing the acreage to three hundred acres that incorporated careful landscaping, manmade lakes and formal gardens, all falling under the name Cranbrook, after his family's British homeland.

Once the Booths readied the original farmhouse to use as their temporary summer home, plans began to build Cranbrook House. Designed by Albert Kahn, the English Arts and Crafts manor included Pewabic fireplace facings in five of the home's bedrooms. With Cranbrook House completed in 1908, Booth went to work shaping other parts of the estate he planned in dedication to education, the arts, sciences and religion, with buildings and designs that gave a tangible nod to the Arts and Crafts movement he so loved.

Booth then incorporated Pewabic in fireplace facing, chimney pots and ornamental tile on Brookside Cottage. In 1916, he commissioned architect Marcus Burrowes to build Flowing Well, a tall, beautiful fountain built into the stone wall that separates the property from Cranbrook Road. Better known as "Rainbow Fountain" because of the rainbow that appeared through the sun and water the first time the fountain flowed, it featured Pewabic tiles of varying sizes, colors and iridescence and continues to today, although the fountain was restored using modern tiles in 2003.

In 1916, Booth also began plans for the next stage of Cranbrook House. As he had before, he hired Kahn to design the addition and Perry Stratton to design twelve projects, which included Pewabic tiles in a sunroom, a vestibule, a workroom, a fountain and a stove, among others. When Perry Stratton submitted her concepts, the proposed cost startled Booth, who apparently hadn't considered the possibility of a price increase in the decade since Pewabic's original work at Cranbrook House. In correspondence to Perry Stratton, he suggested ways to cut expenses, including using a less expensive tile interspersed with Pewabic's.

Immediately offended, Perry Stratton disengaged entirely, canceling a scheduled meeting with Booth at the pottery. Unfortunately, Booth did not receive word in time and arrived at Pewabic only to be turned away by staff saying that Perry Stratton was unable to meet. Letters from Perry Stratton awaited Booth once he returned to Cranbrook House, first attempting to catch him in time to cancel their meeting and then another in which she listed several reasons why "it is better for us not to take part in the work" and how it would be unfair to intermingle tile companies in the project. A flustered Booth penned a four-page strongly worded rebuttal to Perry Stratton dated October 21, 1918, part of which reads:

> As I passed along on my trip to the office the other day I was invited not to come to the Pewabic Pottery, and again later a message "don't come" and when I returned home "don't come" and of course what could it mean but that my friend was attacked with a distressing malady and was incapacitated or solicitous for my welfare, so when all my efforts to reach you by phone found only a dead line I became still more alarmed and then when your letter arrived I was surprised for I could then see why you were in hiding but I could not admit a justification unless perchance, I was painted in large letters forever on your "black list."
>
> Somehow I have a feeling that you could not look me in the eye and tell me all that you wrote; you knew you would have to fill in those spaces

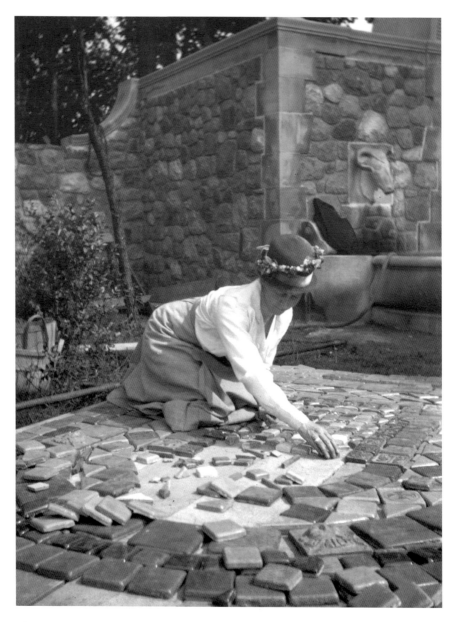

Mary Chase Perry at Flowing Well, Cranbrook, 1916. The fountain, more popularly referred to as "Rainbow Fountain," was restored with reproduction Pewabic tiles in 2003. *Courtesy of the Cranbrook Archives.*

One of Mary Chase Perry Stratton's porcelain china painting plates, circa 1895–1909. *Courtesy of Pewabic Pottery.*

Monumental Vase, circa 1910–15. *Courtesy of Pewabic Pottery. Photo credit Scott Lane.*

Uranium Vase, circa 1920–40. Uranium in the glaze process helped Mary Chase Perry Stratton achieve this vessel's bright orange color. *Courtesy of Pewabic Pottery. Photo credit Scott Lane.*

This Pewabic multicolored hexagon served as a glaze sample used in the early days. *Courtesy of Pewabic Pottery. Photo credit Scott Lane.*

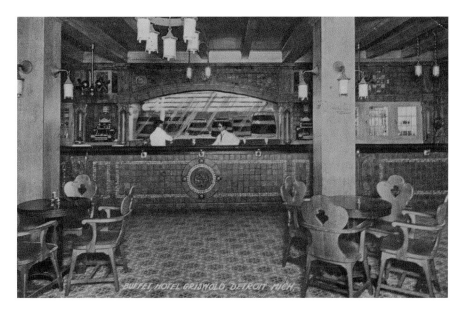

Above: A hand-colored postcard postmarked February 1911 shows the Pewabic tiles in the "buffet" or bar of the now gone Griswold Hotel in Detroit. *Courtesy Cara Catallo.*

Below: Pewabic's mosaic ceiling on the loggia at the Detroit Public Library's Main Library. *Courtesy of Pewabic Pottery.*

Above: The Pewabic Storybook Fireplace at the Detroit Public Library, Main Library. *Courtesy of Pewabic Pottery. Photo credit Jason Keen.*

Below: Ceiling detail in the North Apse, Crypt Church, Basilica of the National Shrine of the Immaculate Conception, circa 1924–31. *Courtesy of the Basilica of the National Shrine of the Immaculate Conception, Washington, D.C. Photographer Geraldine M. Rohling.*

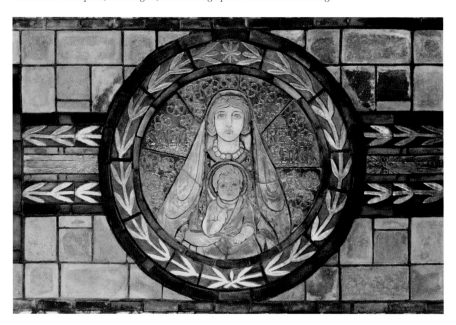

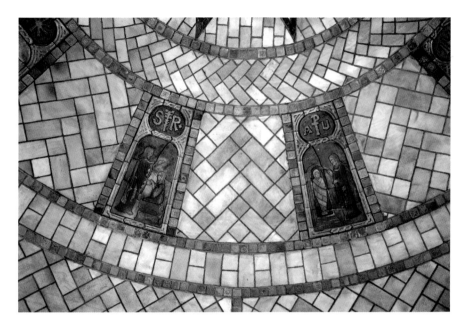

Mary and Baby Jesus medallion, Basilica of the National Shrine of the Immaculate Conception, circa 1924–31. *Courtesy of the Basilica of the National Shrine of the Immaculate Conception, Washington, D.C. Photographer Geraldine M. Rohling.*

Oftentimes on the larger, more complicated installations, Pewabic would make more than one mold, just in case something happened in transit or during installation. The Holy Spirit medallion that hangs in gallery space at Pewabic matches the one installed at the Basilica of the National Shrine of the Immaculate Conception, Washington, D.C. *Courtesy of Pewabic Pottery. Photo credit Scott Lane.*

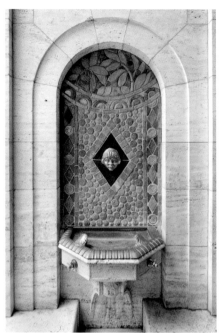

Above, left: Renovations in the 1980s revealed two Pewabic Pottery ceramic niches—and the two basket designs above them—that were original to the Detroit Institute of Arts. *Courtesy of Pewabic Pottery. Photo credit Jason Keen.*

Above, right: *Drinking Fountain of Early Pompeian Tradition*, Detroit Institute of Art, circa 1927. *Courtesy of Pewabic Pottery. Photo credit Jason Keen.*

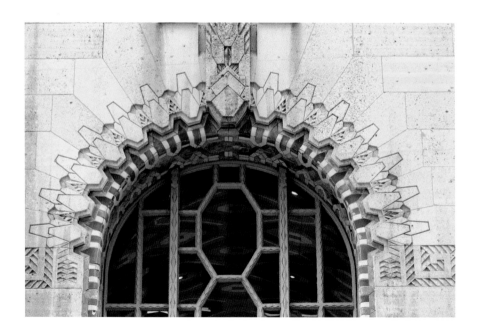

Above: In the late 1980s, Pewabic designed and installed the large medallion in the floor of the Detroit Institute of Art's Rivera Court. *Courtesy of Pewabic Pottery. Photo credit Jason Keen.*

Opposite, bottom: Above the Guardian Building's Congress Street entrance, a repeated trio of symbols of thrift (beehive), money (eagle) and commerce (caduceus) adorn the Pewabic arched border. *Courtesy of Pewabic Pottery. Photo credit Jason Keen.*

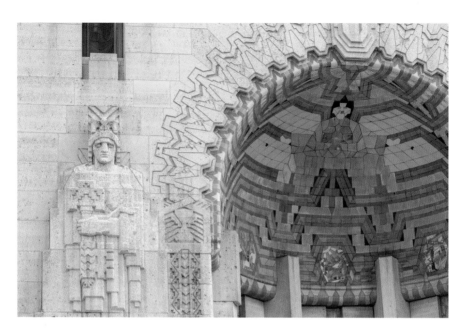

Above: The Griswold Street entrance of the Guardian Building features the Pewabic tiled half-dome of an aviatrix with outstretched arms to symbolize progress and the three small medallions below to signify the commercial themes of industry, agriculture and transportation. *Courtesy of Pewabic Pottery. Photo credit Jason Keen.*

Left: This "Grueby green" Pewabic lamp base, circa 1904, exemplifies Perry's hand ornamentation on pottery. The peacock was a prevalent symbol in both the Arts and Crafts and Aesthetics movements and so appeared often on Pewabic pieces. *Courtesy of Pewabic Pottery. Photo credit Scott Lane.*

Above: Elongated blue and white rectangular peacock tile, circa 1907. *Courtesy of Pewabic Pottery. Photo credit Scott Lane.*

Below: Pewabic's modern five-by-seven embossed and hand-painted peacock tile originates from a 1909 form that features Mary Chase Perry's initials. Perry possibly created the tile to commemorate her friend and art collector Charles Lang Freer's purchase of James Whistler's *Peacock Room*, which he had dismantled in England and shipped to Detroit, to be rebuilt it in his home. It now belongs to the Smithsonian Institution's Freer Galley of Art in Washington, D.C. *Courtesy of Pewabic Pottery. Photo credit Scott Lane.*

Above: The Detroit People Mover's Cadillac Center station features the Pewabic tile installion "In Honor of Mary Chase Stratton," designed by Diana Pancioli. *Courtesy of Pewabic Pottery.*

Below: Pewabic Pottery in 2016, more than a century after its founders, Mary Chase Perry and Horace J. Caulkins, commissioned W.B. Stratton to design it. *Courtesy of Pewabic Pottery. Photo credit Scott Lane.*

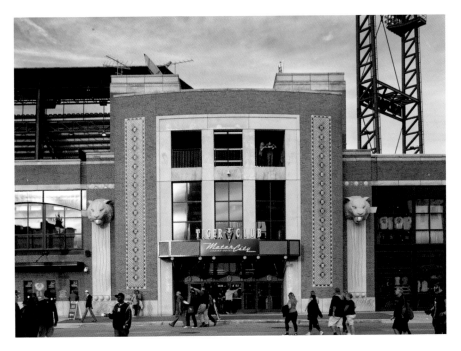

In 2000, Pewabic created the "Old English D" tiles for Comerica Park, home of the Detroit Tigers. *Courtesy of Pewabic Pottery. Photo credit Jason Keen.*

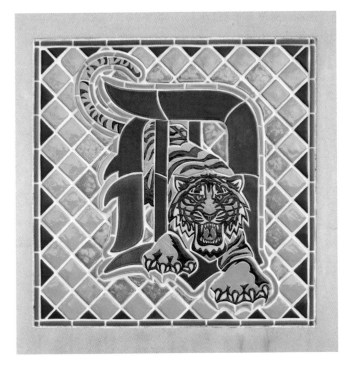

The Detroit Tigers' "Old English Ds" adorn Comerica Park. *Courtesy of Pewabic Pottery. Photo credit Jason Keen.*

The six-by-six pinecone, here in Pewabic green, is an enlarged reproduction of Mary Chase Perry's original three-by-three pinecone tile, originally designed for a circa 1907–10 fireplace installed on East Grand Boulevard in Detroit. It later became one of Pewabic's most popular designs. *Courtesy of Pewabic Pottery. Photo credit Scott Lane.*

This modern-day seven-inch round Detroit tile or trivet, here in two-toned peacock color, celebrates Detroit's skyline and river. *Courtesy of Pewabic Pottery. Photo credit Scott Lane.*

Above: Pewabic giftware: a large petite vase in metallic, a classic vase in iridescent and a Pewabic pint, introduced in 2014, in cinnamon. *Courtesy of Pewabic Pottery. Photo credit Scott Lane.*

Below: The circular medallion featuring the Scottish Rampant lion in the narthex of Bloomfield Hills' Kirk in the Hills welcomes visitors with the inscription, "Enter His Gates with Thanksgiving and His Courts with Praise." Its four corners include the seals of the United States, Michigan, University of Michigan and the City of Detroit. Featuring a multitude of custom tiles within the narthex and sancutary, the Kirk is believed to be the last of Mary Chase Perry Stratton's ecclesiastical work. *Courtesy of Kirk in the Hills.*

Left: W.B. Stratton designed the large Pewabic scarab imbedded in the south façade above the main entrance of the Scarab Club, 217 Farnsworth, Detroit. The Strattons were members of the club, charged with enlightening the community about the arts. *Courtesy of Pewabic Pottery. Photo credit Jason Keen.*

Below: Nicole Marocco throws a vessel for Pewabic Pottery. *Courtesy of Pewabic Pottery. Photo credit Cybelle Codish.*

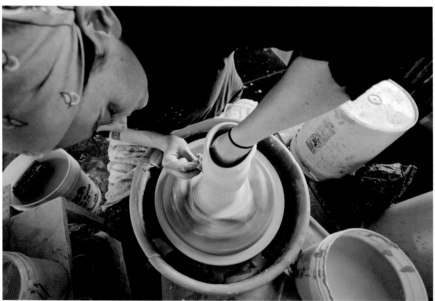

Right: Neil Laperriere arranges an architectural tile order on the floor of Pewabic Pottery, one of the last steps before delivery. *Courtesy of Pewabic Pottery. Photo credit Cybelle Codish.*

Below: Alex Thullen spray glazes a vessel near the original clay-making equipment and pug mill. *Courtesy of Pewabic Pottery. Photo credit Cybelle Codish.*

Sherlyn Hunter holds a rubber form from which she makes the plaster mold for the "Spirit of Detroit" tile. *Courtesy of Pewabic Pottery. Photo credit Cybelle Codish.*

Mary Chase Perry at Flowing Well, or "Rainbow Fountain," at Cranbrook, 1917. *Courtesy of Pewabic Pottery.*

between the lines with all the things you knew, and you thought, while you were writing those diplomatic lines.

But, my long time friend, I am not so easily disposed of. You are in fact, apt to stumble over me any fine morning sitting on your door step and certain you are to repent even if it is to get rid of a pestiverous fellow. In this case I feel I have one advantage as you cannot prove unfriendliness, neither can your knightly husband work himself up into a state of wrath to put an end to my persistency or to punish me as a nuisance for I am quite persuaded as he too is my friend, so the case narrows down to your "wicked partner" he whose stern countenance can only be excelled by my own but who is quite as harmless I am sure.

Booth continued to deride his old friend for surmising that mixing Pewabic tiles with another tile company's would cause a disservice to either:

How could I ever expect to realize the joy of their possession under the same roof with Mercer tile which for now these many years have seemed to behave themselves so well; yes, even without a passing note from those Pewabic damsels in gray and blue and cream upstairs. I must assume, therefore, that you suspect Pewabic tile of a disorderly and unsympathetic characteristic they really do not possess.

I am puzzled. Is it really so that my Pewabic jars of which I have been so proud have suffered being in the same house with homlier [sic] ones of many makes? Do you really think so? Must I abandon these too? And now that you know I have many others, will you withhold the privilege of still other jars and vases?

Finally, Booth concluded his letter asking Perry Stratton would he have written such a lengthy, heartfelt letter "if after these days I still thought only of tile." Booth's efforts went unrewarded, and Perry Stratton did not budge from her stance, in effect silencing the pair's twelve-year friendship built on collaboration, support of mutual interests and admiration. Because Pewabic was busy at the time, Perry Stratton focused herself on several other large-scale projects in the works.

Roughly seven years after their apparent falling out, Booth was in the early stages of designing Christ Church Cranbrook, which seemed a measured monument to the Arts and Crafts movement, employing craftspeople and artisans to incorporate their talents into the Gothic-style church. In a letter dated June 4, 1926, Booth directed his architects at B.G. Goodhue Associates to consider Pewabic mosaics for the baptistery vault, calling attention to Perry Stratton's accomplishments at the National Shrine and at the Detroit Public Library's loggia ceiling. "In her work in the Detroit Public Library I think it is all of the smaller variety of mosaic. The color particularly is generally very good," he wrote, adding, "I should be pleased if we are able to have a piece of Pewabic work in the Church and have thought the most suitable location would be the vault of the Baptistry [sic]."

Perry Stratton was receptive. Booth gave his old friend the artistic freedom he inadvertently reneged during their last project together. Perry Stratton was able to decide the size of the mosaic's tesserae, how to incorporate symbolism and even her budget. After she and Booth spoke, she invited the architects to visit her at Pewabic to "gain an idea of what we have done and might do" and soon went to work researching what the design should be, seeking to pay homage to the Holy Spirit's seven gifts.

"We have used our libraries and most of the clerics of our acquaintance, with famine for result," she wrote in a June 14, 1927 letter. Perry Stratton persisted with her research, and the Christ Church Cranbrook installation culminated in a moving vestige on the church's baptistery ceiling. As had occurred in other ecclesiastical installations, symbols guided Perry Stratton. She depicted the seven gifts with wisdom as a beehive, a symbol Booth

repeated throughout Cranbrook; understanding as a lamp; counsel or guidance as a star; fortitude or strength as an oak; piety as a cross; knowledge as a book; and godly fear or peace as a dove. Pewabic also created tiles for the floor of the baptistery and floor tiles throughout the sanctuary, altar and choir, as well as drinking fountains.

With Christ Church underway and their former rift behind them, Booth continued to incorporate Pewabic as his Cranbrook community took shape. Since 1926, he had enlisted Finnish architect Eliel Saarinen to design the buildings that would make up Cranbrook School for Boys, along with an infirmary, dining hall, dormitory and academic building. Saarinen asked Pewabic to create brownish-beige tiles for the facing and hearth in Cranbrook's Hoey Hall, incorporating several tiles depicting athletes participating in football, track, tennis, baseball and basketball designed by his son Eero Saarinen. Pewabic also created several fireplaces on this part of campus, completed in 1928.

In 1929, Eliel Saarinen hired Pewabic to create a fireplace he designed to be part of his room installation for "The Architect and the Industrial Arts: An Exhibition of Contemporary American Design" exhibit at the Metropolitan Museum of Art in New York City. After the exhibit, workers disassembled the room and shipped it back to Michigan. Pewabic repaired and replaced some tiles damaged in transit, and the fireplace went on to Cranbrook to be installed in Saarinen's own Cranbrook Academy of Art residence, which he had recently designed as the CAA's first president and resident architect. After years as a residence, the building eventually became a museum known as Saarinen House. It also includes Pewabic bathrooms, and its courtyard hosts Pewabic comedy and tragedy masks that some believe were designed by Eero Saarinen and carried out at Pewabic.

Around the same time Saarinen finished his residence, he designed the next element of Cranbrook's campus: Kingswood School for Girls, which he completed in 1931. Like Saarinen House, Kingswood School is quintessentially Saarinen, including rugs woven by Saarinen's wife, Loja; furniture designed by son Eero; and interiors by daughter Pipsan. However, the building's main entryway was purely Pewabic, known as the Green Lobby for its sea of green tiles that pave the floor and dress the walls, including a fireplace and wainscot and even climbing up a nearby stairwell. Unfortunately, 1997 renovations to the Green Lobby replaced the original Pewabic tile floor with a markedly different tile by another maker, all but proving Perry Stratton's long-ago concern of what might happen at Cranbrook House. Plans are underway to restore the Green Lobby tiles with Pewabic.

Kingswood features the largest collection of Pewabic tiles on the Cranbrook campus, still present in mantels in the commons room and the library, as well as in the building's forty-nine dormitory bathrooms. Although the results are beautiful, Booth's contractor became infuriated at Pewabic during the project for repeatedly being late with deliveries. The contractor sent workmen to Detroit more than twenty times to pick up finished tiles, working whenever possible to try to keep the job on schedule and sending Pewabic critical notes.

George Booth wasn't the only Booth with whom Perry Stratton worked at Cranbrook. Booth's son, Henry Booth, an architect himself, commissioned Perry Stratton to integrate Pewabic throughout Thornlea, the home he and his wife, Carolyn Farr

A modern-day photo of the Pewabic tile walls going up the Green Lobby staircase at Kingswood School, Cranbrook. *Courtesy of Pewabic Pottery.*

Booth, built on Cranbrook Road across the street from Kingswood School. Pewabic tile flows through the great 20,840-square-foot house Henry Booth designed himself—from tile floors and fireplaces to almost the entirety of four bathrooms, plus windowsills and even heating grates. He continued to use Pewabic in subsequent additions in following years, and Perry Stratton expressed her gratitude of their working relationship in a letter dated October 25, 1926: "I wish to say that it has been 'fun' to work with you. You and Mrs. Booth have shown so much understanding of plastic material, both its possibilities and especially its limitations, that it freed us to work out problems in a direct way and naturally." She went on to compliment the Booths on building a house that is theirs alone, "thistle and all," referring to Henry Booth's nickname, "Thistle."

In 1932, at the annual meeting of the Detroit Society of Arts and Crafts, which honored Perry Stratton, George Booth introduced his old friend, their

unpleasantness well behind him, noting, "We cannot appear to be surprised at Mrs. Stratton's achievements or even to praise her over much, for knowing Mrs. Stratton, we know that she could have done no less. She has the habit of fine achievement." A standing ovation followed.

"They had forgotten all about the pottery. They were thinking of Mary Chase Stratton herself, of all she has stood for in Detroit for the last 30 years, of her fine craftsmanship, her modesty, her cavalier attitude toward herself and her unfailing gallantry toward others," wrote Florence Davies in her *Detroit News* article "Artists Honor Mrs. Stratton," December 1, 1932.

THE ECCLESIASTICAL INSTALLATIONS

"One church led to another."

Through their friend Freer, Caulkins and Perry Stratton met New York architect Ralph Adams Cram of Cram, Goodie and Ferguson, expanding their architectural opportunities into ecclesiastical installations. In 1908, Cram asked Pewabic to consider tiling the floor of the Cathedral of St. Paul, the limestone Late Gothic Revival church he was building at 4800 Woodward Avenue in Detroit. Although Pewabic hadn't undertaken such a job before, Cram saw potential in paving the sanctuary's interior in Pewabic tiles and asked Perry Stratton to draw up plans.

To consider design concepts, Cram suggested Perry Stratton go east to review other new churches the firm had built. Perry Stratton intentionally resisted to avoid having other interior treatments influence her own, even subconsciously. Instead, she decided to do what she always had: she turned to books and research with an eye on, as she said, getting into the spirit of the project. She pored through books at the public library and at the Stratton and Baldwin architectural offices, becoming absorbed in Gothic ecclesiastic styles and symbols perhaps worthy of incorporating.

In the end, Perry Stratton decided to keep the cathedral's narthex simple, using unglazed brown tiles on the aisle, paired with unglazed cobalt blue tiles to naturally guide attention toward the sanctuary. In the choir, Perry Stratton selected smaller tiles with ivory and brown glazes, with a border of green-and-blue Gothic trefoils—"praise by song and by harp, with the tetramorph supplying the mystic suggestion," she wrote.

Perry Stratton saved richer blues for within the sanctuary and for the approach to the communion rail, almost building to a crescendo. In the center, a gold circle "surrounded an interlacing cross, in the heart of which was to be a plaque with a pelican modeled on its surface." As she saw it, the designs were both rich with "ecclesiastic meaning" and provided an aesthetic texture to embellish the cathedral.

As crisp as her designs were, Perry Stratton struggled to translate her ideas into models, writing, "I literally had to complete dozens of modeled designs in order to summon enough conviction to make the idea come through—or come true, which meant the same thing to me."

When Cram saw what she proposed, he applauded Perry Stratton for so thoroughly studying his book about symbolism. Apologetically, she admitted that she didn't know he had even written one. Impressed rather than offended, Cram applauded Perry Stratton for so thoroughly doing her homework, she recalled.

Cram also liked Pewabic's "handmade look," wrote Perry Stratton, adding that "his admonition was, 'Make them as well as you can by hand and they will still be crude enough,' which was true."

The pottery began what was its largest-scale architectural tile order to date. With the tile molds ready, the work quickly reached Pewabic's kilns. Tile colors stretched from what Perry Stratton dubbed a "light greenish-blue to a deep dull blue in the same tile." Overall, the St. Paul installation included 250 ecclesiastical design inserts.

Perry Stratton described her goals with the cathedral project in a chapter she wrote in *St. Paul's Cathedral Detroit, Michigan: One Hundred Years, 1824–1924*:

> *A halo of tiny tiles in antique gold lies upon the arms of the cross, while in the very midst is an iridescent disc bearing the form of a pelican feeding her young with drops of her own blood, the symbol of the mother church sustaining the young churches....Such is the tiling in the sanctuary floor, the center and heart of the whole design. Nowhere else in the world, we believe, is there a floor bearing the slightest resemblance to this of St. Paul's. Perhaps its closest relationship, and this in feeling only, lies with the exquisite mosaics in the ceiling of the Tomb of Galla Placidia, Ravenna.*

Caulkins and Perry Stratton were satisfied with their outcome. "While ignoring many long-established conventions in paving, we had been able to maintain consistently the spirit of the Gothic period of which the Church is so splendid an example," Perry Stratton wrote.

St. Paul's held its first service in 1910, and in 1912, it was designated a cathedral. On April 9, 1947, Detroit and the country directed its attention to St. Paul's for the funeral of automotive giant Henry Ford, with six hundred people in attendance and reportedly twenty thousand rain-soaked mourners outside. The U.S. secretary of the interior listed it in the National Register of Historic Places in 1982.

St. Paul was the first of many church installations for Pewabic, both in metropolitan Detroit and nationally. "One church led to another," Perry Stratton wrote in her memoirs. Although Perry Stratton appeared to keep her personal religious affiliations or affinity private—or at least no accounts seem to outwardly display any—her diligent research, preparation, deep-seated respect and understanding regarding these installations called to mind Perry Stratton's father, a man of great faith, who died when she was ten years old.

Pewabic's religious installations each managed to stand on its own individual merit, with beauty and meaning befitting a place of worship. In true Perry Stratton fashion—to always keep the process fresh and interesting—she incorporated and factored in each church's architectural style and surroundings, as well as its architect's mission with the project.

Perry Stratton's approach departed from the way sanctuaries and vestibules usually used the same or similar materials. She decided that these areas should have greater contrast to better match their individual purposes as opposed to each other. A church's prominent spaces, she felt, should be adorned in a way that demonstrates gloriousness, and the more auxiliary spaces should be more subdued. Architects appreciated the well-researched and thoughtful insight she shared, and because of it, they often gave her greater freedom to express these spaces in the way she saw fit.

She also proudly brought color into the churches. She delivered rich greens and blues amid the red brick exterior façade of St. Patrick's in Philadelphia. Inside, the floors acted like a modest path of simple unglazed tile, yet the risers to the steps leading to the sanctuary shone with iridescent glazed tiles and inviting borders of gold.

In 1914, architect Bertram Goodhue sought Pewabic for his House of Hope, a Gothic church in St. Paul, Minnesota. Again, Perry Stratton took into consideration the locale when creating her design. "We thought it might add to their pride in the resources of their state, if we used a very nice clay from Red Wing, Minn.," Perry Stratton recalled in her memoirs. "It was a warm buff and when coppery iridescent glazes were added to portions of the designs in the semi-glazed tile, the effect was sunny and cheerful."

A handful of the many early churches that incorporated Pewabic into their structures include St. Matthew's Church in Washington, D.C.; the Sanctuary in St. Luke's Church in Evanston, Illinois; St. Matthew's Cathedral, Laramie, Wyoming; and St. John's Church in Grand Rapids. Locally, Pewabic played a part in countless churches, such as Most Holy Redeemer Church in southwest Detroit, Bethel Evangelical Church on East Grand Boulevard in Detroit and the North Woodward Congregational Church in Detroit, among others.

While each church commission was meaningful to Perry Stratton, none measures quite so high as the work Boston architect Charles Maginnis of the firm Maginnis and Walsh asked Pewabic to undertake with the National Shrine of the Immaculate Conception.

Maginnis traveled to Detroit to discuss the likelihood of Pewabic creating ceiling tiles to buoy the planned structure's naturally restrained crypt, as well as to provide other embellishments to decorate the significant space. In a letter to Maginnis dated February 23, 1924, Perry Stratton shared with the architect several ideas and sketches for the committee to consider, as well as her earnest desire to do right:

> *With some kindly explanations from you, they may suggest the beginning of our idea and with symbolic backgrounds and an interpretation, which could only be expressed in ceramic material. As far as I know—the type of glaze and general manner of expression is unlike anything done before. I do hope it still appeals to you as good. We must not do anything else and I trust you help me and to protect me by severity! Your coming was a great lift of inspiration which we needed.*

Maginnis shared the information and two days later had a signed contract enlisting Pewabic "for manufacturing and installing in the crypt of the National Shrine at Washington, D.C., colored faience and mosaic work."

The man behind the project was Bishop Thomas Shahan, founder of the National Shrine and rector of the Catholic University of America. It was through Shahan, an aficionado of early Christian art, that Perry Stratton—along with her husband, W.B. Stratton, the pair having married in 1918—sailed abroad for the first time in March 1924, to study early Christian symbolism in the catacombs of Rome. The trip was also an opportunity for Perry Stratton to learn more about Europe's rich traditions of artisanal craftsmanship by visiting Portugal and Spain before finally arriving in Italy to study sites in Rome and Ravenna.

A 1924 railway ticket that belonged to William Buck Stratton and Mary Chase Perry Stratton remains as a souvenir of their trip abroad. *Courtesy of Pewabic Pottery.*

Such a lengthy trip away from the pottery was a rarity for Perry Stratton, and this trip to Europe came at a time when she could use the time away with Stratton. Her business partner Horace Caulkins had died a year earlier, in 1923, and Perry Stratton felt the substantial loss of his guidance and friendship. Minnie Peck Caulkins, for the most part, preferred to be a silent partner, putting even more of the pottery's responsibilities squarely on Perry Stratton's shoulders. Researching Pewabic's largest installation to date enabled Perry Stratton to step outside her busy day-to-day life of living and creating art to instead be on the receiving end of art's intended message. There she could bear witness to ceramics used architecturally almost everywhere.

The experience resonated with Perry Stratton on multiple levels. She relished confirming that she honored traditional craftsmanship, seeing how the Moors centuries earlier extracted their colors at Alhambra in ways she found to be familiar: "Blues from cobalt. Violets from manganese. Yellows from iron, Greens from copper, just as I had done them more than a thousand years later. My mind had evidently worked in the same primitive channel. It was all so direct—no mixing of oxides—only lighter or darker according to the percentage of the colorant."

Perry Stratton wrote how she felt at ease, surrounded by what she knew best. In the catacombs, she was able to be at one with her research, writing in an article, "There, only, could one seek the sense of reality to help express

thought after the early manner. In these caverns of darkness, where the early Christian martyrs worshipped and suffered, one could not help acquiring a sympathy with their expressions depicting the very essence 'of spiritual belief and hope.'" She treasured the challenge of interpreting the catacombs in clay and glaze.

The couple savored all the trip had to offer, even though it meant Stratton missing out on some much-needed work back home. They sketched various sites in consideration of the National Shrine. As Shahan had hoped, the journey provided Perry Stratton with almost divine inspiration. By now, his life's work was dedicated to the National Shrine being built, and she delighted in working on his behalf, touched by the care he put into the structure's plans. Perry Stratton hoped that the knowledge she brought back from the trip would sufficiently fulfill the bishop's wishes, writing:

> It all unfolded so simply into a decorative whole of prophecies, promises and fulfillments, with motives and characters falling into their parts like a proven drama. The biblical story was so woven together that a scheme of decoration was outlined in my thought. On the train on the way to Washington to confer with the Bishop, I was able to make a diagram, expressing what was in my mind.

Perry Stratton's sincere admiration for Shahan left her tongue-tied. "It was, perhaps, one of the proudest moments of my life when the kindly and most scholarly of men approved the biblical sequence. It was a definite satisfaction to think that I had come anywhere near meeting his literary exactness," she wrote.

A year and a half later, those drawings became carefully glazed ceramics, numbered and wrapped in paper—sometimes when they were still warm from the kiln—and placed in barrels to ship to Washington, where a small force of men entrusted to carry out Pewabic's installation had temporarily relocated. Perry Stratton, too, frequented the site, welcoming the opportunity to better know the clerics and sisters and see what the space meant to those who made pilgrimages there, as well as the university students. It was a world away from the pottery, and although she was there to work, Perry Stratton found herself at peace, far from the everyday demands of the business.

In the crypt church, Perry Stratton's plans conveyed something she considered original: she carried the decorations in the great arches between the vaults and the apses, with the subject matter as motifs in historical sequence. In the first arch, three roundels show the women of the time of

Monsignor McKenna, Stratton and an unnamed person, most likely a Pewabic employee, watch as a truck unloads for installation, 1924. *Photo by Buckingham Studio. Courtesy of Pewabic Pottery.*

Workers carefully install the Holy Spirit medallion created by Pewabic Pottery within the crypt church of the Basilica of the National Shrine of the Immaculate Conception. *Courtesy of the Archives of the Basilica of the National Shrine of the Immaculate Conception, Washington, D.C.*

Perry stands outside the National Shrine of the Immaculate Conception with shrine dignitaries Monsignor McKenna, Charles Maginnis and Frederick J. Murphy. *Photo by C.O. Buckingham, October 1, 1924. Courtesy of the Archives of the Basilica of the National Shrine of the Immaculate Conception, Washington, D.C.*

the prophesies, with Ruth, Miriam and Sarah raising their hands in prayer, as she described in her autobiography:

> *The entire Shrine ideal is one of devotion to the Virgin Mary, and as far as possible the women in scripture are used as themes for decoration, especially stressing the Marys. Once when Bishop Shahan remarked kindly that it was fortuitous they had found a "Mary" to help in the project, I at once replied from the bottom of my heart, that the marvelous part was the*

opportunity it gave me to make my ceramic dreams come true. Not once in a thousand years is there such a favorable combination of conditions presented to an eager and work-hungry craftsman.

Perry Stratton wrote in a 1925 issue of *Michigan Women* that part of the honor she felt working on the National Shrine was because "it is one of the few churches, in this country at least, devoted to the ideals of Womanhood—essentially to the Spirit of Motherhood—in that it is dedicated to Mary, the Mother of Jesus."

Unlike other ecclesiastical installations, the National Shrine work strayed from mosaics and their multitude of tesserae. Instead, Pewabic created a mural-like effect using deeply incised large ceramic pieces—fourteen-inch or so—with carefully applied slip glaze. Surrounding the medallions or panels, pieces went from "unglazed fireclay" to slip glazes and finally the brightest of iridescent golds. This "pictorial theology of the first three centuries after Christ" used a technique that some say was not used before—or, as a shrine booklet suggested, at least not recorded.

Beyond the ceiling, Perry Stratton and Pewabic created the fourteen Stations of the Cross in a style closely related to the art found in the catacombs, as Shahan had hoped.

An article that originally ran in the *Detroit News* on April 19, 1925, referenced Pewabic's work: "Probably one of the most ambitious projects in the field of ceramics as applied to architecture ever undertaken in this country is going forward here in Detroit. The kilns were busy firing thousands of tiles for the Crypt of the National Shrine of the Immaculate Conception in Washington, D.C."

The National Shrine's "foundation stone" was laid in 1920, and construction of the Crypt Church began in 1922. By the end, Pewabic had done $65,000 of work on the crypt in roughly seven years total. Construction of the lower level finished in 1931. Shahan died the following year, stalling construction until 1954. Dedicated on November 20, 1959, and named a basilica in 1990, the Basilica of the National Shrine of the Immaculate Conception is the largest Roman Catholic church in North America and is among the ten largest in the world.

The National Shrine would not be so complete without Perry Stratton's carefully considered Pewabic designs, said Geraldine M. Rohling, PhD, MAEd, the archivist and curator of the Basilica of the National Shrine of the Immaculate Conception. "The heart and soul of this church is the crypt church. If you understood Bishop Shahan: It is the most cohesive spot. Once

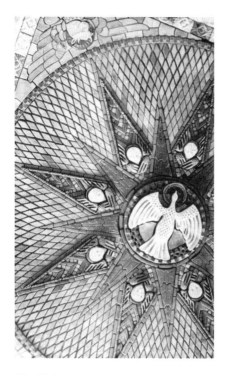

The Holy Spirit takes the form of a bird in the Pewabic installation at the National Shrine of the Immaculate Conception. *Courtesy of the Archives of the Basilica of the National Shrine of the Immaculate Conception, Washington, D.C.*

you walk in there, everything fits," explained Rohling, adding that Shahan wanted the church to be the reflection of all the glories of religion. He sent Perry Stratton to Rome to experience the catacombs so that she could bring a sense of it back for the crypt church. "She's one of the few artists to take the frescoes of the catacombs and to translate them," said Rohling, adding that the combination of Guastavino and Pewabic tiles completes the process. "It's the two of them together that make the space. Without the two of them coming together it would not be the same."

Add architect Maginnis, himself an ecclesiastical art author, and it was a winning combination, said Rohling, the likes of which have not been seen since. "I've never used the word *masterpiece* with them because I think their work goes beyond that," Rohling noted. "All of the other things brought them to this point. It's a point of perfection in their craft that others have not been able to achieve....You truly do feel like you're in a catacomb. You feel that you're in a holy place and it is because of her artwork. Sometimes an artist is only meant to do one thing in life. In Mary's life, I think the Shrine was it. I think it was her pinnacle."

Perry Stratton and Pewabic went on to do a multitude of other church installations. One much closer to home would be her last. The Kirk in the Hills in Bloomfield Hills, Michigan, likely bookended more than four decades of ecclesiastical work.

Although nothing would compare with the magnitude of Pewabic's work at the National Shrine, the Kirk was no small undertaking. The church was the wish of Detroit businessman Colonel Edwin George, who donated his forty-seven-acre estate on Island Lake to build a church modeled after the Gothic-style Melrose Abbey in Melrose, Scotland.

Although George died in 1951—the same year the cornerstone was set in place—the parish followed through with his wishes.

The narthex features plain Pewabic tiles with a border of incredibly individualized tiles, each with its own motif and meaning depicting an interest, hobby or travels of the remarkably industrious and accomplished George. In the center of the narthex, a large Pewabic-tiled medallion reads, "Enter his gates with thanksgiving and his courts with praise," with the Scottish or "Rampant" Lion, a representative of the Royal House of Scots, flanked by the seals of the United States, the State of Michigan and the City of Detroit.

On the east side of the narthex, the Shield of Melrose links the two religious sites, as does the Kirk's Melrose Chapel deep within the sanctuary, featuring Pewabic tile flooring, including several interspersed tiles that feature people engaged in churchly activities, such as getting married or spending time with their children.

Elsewhere on the Kirk campus, in a corridor and vestibule added later, seven historic Pewabic tiles purchased and saved during the original installation are set into the walls, working as a link to the old and the new. These include depictions of the keys to the kingdom; the Agnus Dei (Lamb of God); crusader, patriarchal and Jerusalem crosses; a descending dove; and the hand of God.

Completed in 1958, just three years before Perry Stratton's death, the Kirk today actively keeps alive its Pewabic connection by taking students to the pottery to make tiles to commemorate their confirmation. Each student keeps one of the tiles, but a second tile goes toward forming a cross to hang—alongside others from previous years—in the church's education wing.

PERRY STRATTON'S LATER YEARS
AND THE LEGACY OF PEWABIC

Recollections capturing Perry Stratton's spirit beyond her memoirs seem rare at best. Some accounts exist, including some legends—she always wore a blue dress—but who she was as a person sometimes feels absent or becomes more myth than reality.

Art educator and Perry Stratton friend Murray Douglas noticed that her personality often wasn't apparent in articles about her, so when William Pitney, Professor Emeritus, Wayne State University, asked Douglas to share his memories of Perry Stratton, he did so gladly in correspondence to Pitney dated November 18, 1986.

Douglas and his wife, May, became acquainted with Pewabic Pottery around 1935–36 and continued a working relationship with Perry Stratton until 1942, when their visits turned from professional to social.

A tiny, energetic woman, according to Douglas, Perry Stratton had "pink and white apple cheeks and practical bobbed white hair. Ever inattentive to dress, never without a smudge or two on her face or clothing, she seemed quite unconcerned with mundane affairs," shared Douglas. He described the pottery atmosphere as "happy and encouraging."

Perry Stratton was friendly, casual and inquisitive, an information-gatherer who eagerly sought advice and to exchange ideas. Although he did not consider Perry Stratton temperamental, she did not suffer fools gladly. As busy as she was, Douglas said, Perry Stratton remained independent, diplomatic and sensitive to the feelings of others.

As a teacher, Perry Stratton guided and instructed as much as she saw fit, though never exorbitantly, Douglas said. She encouraged students to think

for themselves and problem solve on their own. She sometimes seemed self-conscious around those with more education, and Douglas described her as a teacher who might not be able to lead far into one specialty or another but could guide an interested students in the right direction:

Sometimes she was reluctantly decisive with students who seemed lacking in self-discipline. She did worry unduly about absentees, the concept of a college undergraduate student signing up for a class because it was in a convenient time slot would never have crossed her mind. Though she was about 70 years old in 1935, she often grumbled about the rigidities of her "little old lady students of thirty to forty years age."

Perry Stratton could hardly understand those less serious than herself, so Douglas estimated that Pewabic offered the Wayne State University classes because the pottery "was financially dependent on its tax relief as an educational institution."

Perry Stratton described her teaching style in a 1934 *Detroit News* article by Florence Davies: "I tell them how to do it, and then leave them alone....I don't want to turn out a lot of Mrs. Strattons, so I try to let each one express his own ideas in design and work out his own salvation."

From modeling clay to the wheel to pouring slip into a mold, all the way to glaze-making and application, students lead with their own concepts, even if at first it seems their ideas aren't quite on track, Perry Stratton explained.

Perry Stratton preferred being one on one, wrote Douglas. "She wasn't truly verbal and seemed to deal with groups only as necessary—and briefly," he said, adding that her teaching style wasn't the "common concept of a room with a teacher up front or circulating. In the first place, all classes were secondary to the operation of the factory, which set some limitations on what students could do. At times one might have to thread one's way around a mosaic being assembled on the floor of the entry hall."

What she did give students was accessibility, once a student could find her somewhere within the pottery. When they did, they found a supportive teacher:

Her queries were incisive and perceptive, concerned less with technique than with one's purposes, sense of achievement and developing needs. Sometimes her responses were so subtle that only later did one realize the significance fully.

She herself was self purposing—would have had to be to develop a flourishing art pottery in an area that offered so few ceramic resources as Detroit—and this was the main aspect of her credo for education; she would do her best to arrange for individuals' learning, but the learning was the learner's problem.

Interested students interested her. Indifferent students seemed to embarrass her; she didn't know how to cope with them.

In a nutshell, Perry Stratton would help lead someone toward one path or another, but the onus was on that student to continue his or her momentum forward, as she had for herself for so many years. On June 1, 1930, Perry Stratton became the first person to receive an honorary Master of Arts degree at the University of Michigan in recognition of distinguished work in crafts. The citation read, "Mary Chase Perry Stratton, Master Artist in the field of ceramics who, in a Pottery conducted in Detroit, has, with constructive insight and cunning workmanship, perfected glazes and decorative pottery, mosaics and tiles prized by collectors and architects throughout the country. Inventive in design and happy in execution."

For the humble Perry Stratton, accolades were for her craft to receive such academic recognition and respect, where she believed it belonged. Such spotlight on the progress made in ceramics mattered more to her than any personal achievement. Three years later, on June 15, 1933, Perry Stratton received an honorary Doctor of Science degree from the Colleges of the City of Detroit, later known as Wayne State University, which held classes at the pottery.

Personally, Douglas described the Strattons as "a warm-hearted childless couple, inclined to take young people interested in art under their wings":

I never met Gwen Lux. I knew she had done some work at The Pewabic because in looking around the attic loft one day with Mary Chase she showed me some small sculptures by Gwen Lux, made when she was 16 years old—The Strattons frequently referred to Alexis, almost as though they were surrogate parents. He did live with them over a period of time (when he was a student, I think). We were introduced one of the times he appeared at the pottery. My impression at those times was that the meetings were more familial than professional.

Alexis Lapteff was the Yale-trained architect who initially worked with W.B. Stratton, until Stratton recognized that he would be a good addition

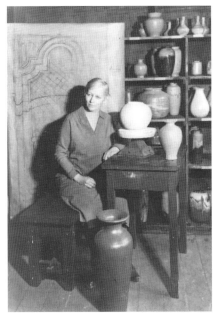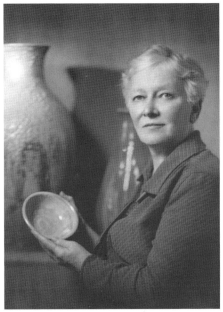

Left: This image of Perry Stratton at the pottery, circa 1932, accompanied a profile of the artist in the September 1983 issue of *Ceramics Monthly*. *Courtesy of Pewabic Pottery.*

Right: Mary Chase Perry Stratton poses holding a bowl, 1941. *Courtesy of Pewabic Pottery.*

to Pewabic. Lapteff found his calling in design work, first at Pewabic, then briefly with Eliel Saarinen and finally at the General Motors' Design Studio. He eventually settled in New York, but always kept in touch with the Strattons.

Douglas's glimpse into the Strattons' private world is priceless, solidifying a sense of two people who singularly sought to advance the arts and did not seek notoriety or attention in doing so. "Both were reticent about their achievements, pleased but somewhat embarrassed by attention. William was a fine architect; designed many fine buildings in this area. Within eclectic skills he inserted many modern concepts and elegant spaces," Douglas noted, adding:

> *The Strattons were as unpretentious people as I have ever known. Both delighted in little unusual discoveries. When we visited them in the old house on Grand Boulevard near Jefferson we saw a striking spiderweb in the upper corner of the double doorway between the parlor and the hall. I think it had been there two years; cleaning people had orders not to disturb it.*

Stratton designed and built Perry Stratton's original 1912 house at 138 East Grand Boulevard before they were married, but this must be another one. When the pair married in 1918—she was fifty-one and he was fifty-three—they lived in the house Stratton designed for her. In 1927, they dismantled it to incorporate many of its elements into what many considered to be Stratton's dream house, at 938 Three Mile Drive in Grosse Pointe Park. The home brought together the couple's dedication to the Arts and Crafts style and incorporated Mediterranean influences from their trip abroad. Along with reusing beams, windows and other materials from the old house, the Three Mile Drive house, as it came to be known, was also a veritable showroom of Pewabic tiles. Some reports claim the house contains 1,700 square feet of Pewabic tile. Douglas wrote about visiting the house:

> *The home that William designed for them on Three Mile Drive in Grosse Pointe was their dream home. It is an exquisite structure. The exterior was constructed by used firebrick taken from the Stroh Brewery's brewing vats when Pewabic was relining them. The brick was a dark fawn color. As the garage doors opened the Stratton touch was revealed in several iridescent tiles hung on the wall to catch car headlights. The multilevel interior was, of course, filled with glazed and unglazed tiles with much fifteenth and*

The Strattons outside their Three Mile House, circa 1927. *Courtesy of Pewabic Pottery.*

William Buck Stratton outside Three Mile House, circa 1927. *Courtesy of Pewabic Pottery.*

*sixteenth century furniture and accessories which they had brought back
from Spain. (One of the items—a brass and copper brazier for carrying
hot coals—became our wedding present.) Her own bathroom was an exotic
display of Pewabic blue and iridescent tiles, including the fixtures. Water
cascaded into the tub. It was a lush setting for a Cleopatra, rather than
Mary Chase, but perhaps she had her fantasies. She also collected such
oddities as a pair of very worn turquoise corduroy trousers which she had
bought from the small Spanish boy who was wearing them, because she
liked the color.*

As Wayne Andrews described it in *Architecture in Michigan*, "The casual
unassuming brick dwelling is one of the really unusual early modern houses
in Michigan."

Sadly, the Strattons only lived there from 1927 to 1937 before having to
leave it. As early as 1930, Pewabic correspondence shows apologies made
for tardy payments, with the explanation of feeling a "jolt" to their finances.
Sales were fewer on the heels of the Great Depression, and the Pewabic
team worked all it could to ride out the storm. The jobs that did come
in were on a smaller scale because the prosperity of earlier days seemed
long gone. Perry Stratton began making ceramic jewelry and buttons to
have added price points people could afford and might buy, and many
of Pewabic's small team of hardworking, dedicated employees had to get

second and third jobs. Perry Stratton actively set out to find architectural jobs that earlier would have sought out to hire Pewabic. Eventually, the Works Progress Administration (WPA) was able to help, but by then the Strattons had seemingly lost their home and Stratton's architecture firm.

The Depression had lasting effects on many throughout Metro Detroit, and in 1937, the Strattons faced the difficult decision of choosing whether to stay in their dream home or keep the pottery business. They chose Pewabic, to continue employing the workers who were like family.

"It was sad that they were able to live in the house for such a short time," Douglas lamented in his letter, about how the couple relocated to Detroit, back to Grand Avenue. A year later, W.B. Stratton was reportedly hit by a streetcar. Several weeks later, on May 14, 1938, the hospitalized seventy-three-year-old Stratton suffered a coronary thrombosis and died.

"The death of William Stratton in 1938 was a severe blow to Mary Chase. They had worked for so many years in tandem," Douglas wrote. "He was frequently at the pottery. His was the first demonstration of throwing on the wheel that I had ever observed. He was quite skilled at this process and made design models for John and other throwers to copy. John [Graziano], who was in his seventies in the late 1930s, I believe, could copy anything. [He was trained in Italy] on the wheel, but left on his own he was inclined to load the thrown pieces with rococo encrustations."

Along with what he did for Pewabic, Stratton was the architect behind the original unit of Henry Ford Hospital, the Brodhead Naval Armory, the Women's City Club and Belle Isle Bathhouse, among others. He was one of Detroit's first city planning commissioners and served as president of the Michigan chapter of the American Institute of Architects and as a member of the Art Founders Society at the DIA.

Emil Lorch, director of the College of Architecture at the University of Michigan, reached out to Perry Stratton about teaching pottery there on September 18, 1933: "The students in Architecture and Decorative Design would thus get some knowledge of clay and firing and glazing which might help them design more intelligently." At the time, it was unrealistic economically, but Lorch didn't lose sight of doing so, and Perry Stratton went on to establish the ceramics studio at University of Michigan, also lecturing there from 1940 to 1942. It was during her time there that she published her small textbook, *Ceramics Processes*, covering the basics about the history of ceramics and laying out for beginners the craft of pottery-making, from the different types of construction and clay to tile, mold-making and glazes. She explained in the foreword that the book exists to prevent "the uninformed

student" from despair. Being mostly self-taught, she could understand the challenges that might lay ahead. "We had no previous training along ceramic lines, and the standard dictionary was our first textbook," Perry Stratton wrote in the *Bulletin of the American Ceramic Society* in 1946. "Of course, we encountered severe, not to say embarrassing, situations while 'learning the trade' and at the very same time 'delivering the goods.'"

In the *Detroit Mirror*, Marion Taylor quoted Perry Stratton as saying that "New methods of producing formulae by algebra can accomplish work on which I might have labored five years," she explained without regret. "It is more efficient, but I love to work. Probably I am the last romantic in ceramics."

In another article, Perry Stratton admitted that the Depression had taken its toll on Pewabic and the arts. She told the *News*' Davies, "It was inevitable that the country should have been flooded with cheap merchandise: The stores, naturally, had to find products which would sell for a very little and the factories had to find an outlet for their wares."

What resulted, said Perry Stratton, was pottery that sold for only a few cents and a flood of "commonplace and sometimes the crude and unlovely....That is why it is important for the individual artist-craftsman to keep working and to keep his place in the community. It is important that, as a country, we keep up our standards, that we do not lose our taste of fine work."

"The machine has come to stay, and has its place in our modern life. But the sincere artist, the artist-designer and craftsman is needed to train our eyes to recognize fine things. That is one reason why hand-made pottery will always be needed and why the craftsman's studio will always have a place in the scheme of things," Davies quoted Perry Stratton.

Mary Chase claimed she could not throw clay on the wheel and I never saw her try to. Julius was the glazeman, though I saw him demonstrating throwing for students a couple of times. Joe seemed to deal entirely with kilns and upkeep, firing; blunging, running the filter press and grog grinder may have his job at times. As you noted she did some contours for John and his assistants to throw. She had once done some freestanding sculpture, but during the time we were around the pottery we were only aware of her doing, aside from tiles, some bas-relief on small boxes, paperweights, and such small items such as models for casting molds, both slip and press. As for glaze formulation, I never heard her claim any knowledge of the field; her glazes seemed to have resulted from juggling of raw materials and firing processes, much like an experienced cook.

And with the glazes that so many connect with Perry Stratton, Douglas wrote that he considered them more empirical recipes rather than formulae, which were "an arrangement of chemical components expressed in chemical [molecular] symbols, I rather doubt that they were much developed by anyone. My work with empirical formulas went as far as *The Potters Craft* lead, but I never met anyone else at The Pewabic who seemed concerned."

One thing that flustered Douglas about Pewabic classes was that students were directed to mark their bisque ware with lines and the name of the glaze or glazes they wanted, even showing where overlaps or drips may be, he wrote. Then Albus, not the students, applied the glaze later and then would fire the pieces for the students. The rationale, he wrote, was to avoid chances of careless contamination of the glazes that might set back Pewabic's production side, which used all the same materials. At the same time, though, Douglas was having elementary-aged students glaze by themselves.

In Perry Stratton's love of "color, color and more color," Douglas wrote, "she showed superior ability. Smoky, delicately iridescent silvery grey sliding into blues of all variety were favorites."

Perry Stratton removes a small piece of pottery from one of Pewabic Pottery's testing kilns. This shot ran in the *Detroit News* on October 9, 1932. *Courtesy of Pewabic Pottery.*

A December 8, 1940 *Detroit Free Press* article paints a picture of Perry Stratton in the pottery in an almost fairytale setting: "The ceramic world beats a path to Mrs. Stratton's door. Technicians come from everywhere to ask her questions, without ever guessing the secrets which give her work its distinctive tone, color and glaze." It continues to describe her color base of "metallic carbonates and oxides," with endless experiments resulting in ice blue, coral pink, primrose yellow and translucent white.

Yet while the public celebrated Perry Stratton's treasured iridescent glazes, they were not her favorite. Perry even grew a little resentful about how the public clamored for

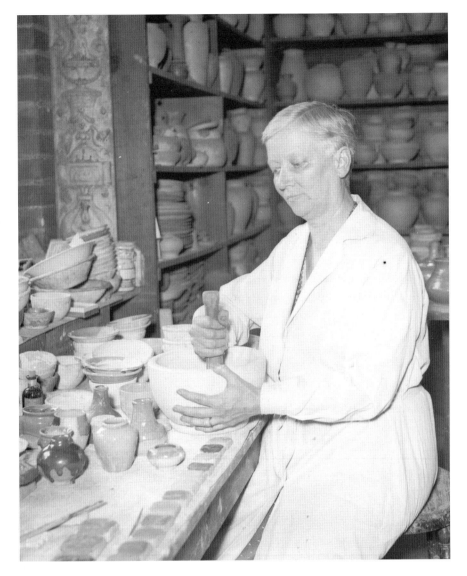

Perry Stratton as a maker, most likely in the 1930s and 1940s. Some reports say that she often donned a blue smock. *Courtesy of Pewabic Pottery.*

the iridescent glazes, leaving her with less time to dedicate to or discover other glazes. Through it all, Perry never strayed all that far from the Morris Arts and Crafts movement, "flavored with Art Nouveau," Douglas wrote. "One of her favorite stories was that of the Italian workman she sent to install Pewabic tile facing in a fireplace in her home who did the job with

such precision that she tore it out that evening and did it over with a freer touch."

Perry Stratton wasn't "overly concerned about utility," Douglas said, pointing to the impracticality of Pewabic's earthenware. As daily dinnerware it would chip easily, and the pottery was not waterproof unless soaked in sealer. The dinnerware that Pewabic did make was largely limited to replacement pieces for the Women's City Club, to which Perry Stratton belonged.

"My feeling is that the 'urge' to try a certain design or method is reason enough for its development," Perry Stratton wrote, with encouragement.

Another time, Perry Stratton explained to Marjorie Avery at the *Detroit Free Press* how new glazes develop: "'I've been playing with this new glaze for four years,' she said pointing to the exquisite pale peach surface of the bowl she was examining. 'It was not until this winter that we got it right. You see, we never standardize our work but are continually searching for better ways of doing things. It's the only way to progress, I think.'"

In 1947, Perry Stratton received the Charles Fergus Binns Medal from the New York State College of Ceramics. Considered the highest honor bestowed on an American ceramicist, the award recognized her achievements in the field of ceramics and Pewabic's celebrated success.

In March 1951, the Detroit Institute of Arts held the first retrospective exhibit of Perry Stratton's work. In an article that ran at the time in the *Detroit News*, Perry Stratton said that initially she hoped to be a sculptor, but her love of color caused her to try pottery. "Blue satisfies me most. But if I had one color to use it would be copper. You can make a fine blue from copper in alkaline glaze," the paper quoted her as saying.

As Perry Stratton grew older, she reflected on her early pieces, considering them interesting but reluctant to determine anything so precious that it shouldn't be destroyed, especially if superior examples came along. Freer had taught her well to only keep the most worthy.

Without Caulkins or Stratton, Perry Stratton lived out the remainder of her life at Pewabic alongside her small team of dedicated craftsmen. In 1946 Perry Stratton described the team as "The best of all small force of loyal helpers, working together at all kinds of projects with perfect unity. We have stuck together through thick and thin and sometimes it has been pretty thin."

By that point, Heerich was already gone, having died in 1938 at age eighty-five at the home he shared with his nephew Joseph Ender and Ender's family. Heerich gave wheel-throwing demonstrations even past age eighty.

Left: A portrait of Mary Chase Perry Stratton, 1928. *Courtesy of Pewabic Pottery.*

Below: Perry Stratton poses with vessels at the pottery, 1941. *Courtesy of Pewabic Pottery.*

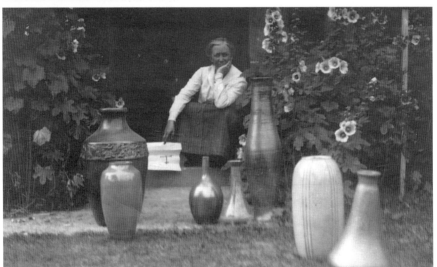

Julius Albus, who started as shop boy and quickly became one of Perry Stratton's closest business confidants and managers, struggled with lung ailments and in 1951 died at age sixty-two.

John Graziosi worked at Pewabic for forty-seven years and died on July 15, 1957. The story goes that Graziosi "retired" several times, but Perry Stratton always talked him into staying on.

Having been a potter for forty-seven years, Joseph Ender died at age seventy-four in August 1959. He reportedly worked up until two weeks before his death.

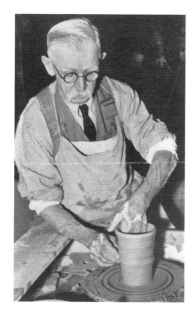

An image of Joseph Heerich throwing a pot on the wheel that ran in the *Detroit Free Press* alongside an article about the potter, March 19, 1934. *Courtesy of Pewabic Pottery.*

Louis Tomasi, who started at Pewabic in 1910, died in 1961. Like Graziosi and the others, Tomasi found outside jobs to help supplement his Pewabic income during the Depression years. Many believe that it was for those workers—to keep Pewabic running—that the Strattons gave up their dream house.

Mary Chase Perry Stratton died on April 15, 1961, at age ninety-four, having outlived her business partner by twenty-nine years and her husband by twenty-three. The *Detroit News* called Perry Stratton "one of the nation's leading ceramicists," noting that the "rare charm of design and singular beauty of glaze developed in her Pewabic Pottery has made her vases coveted by collectors and museums."

She remained active with the pottery until her death, though reportedly struggled with various long-term health issues that slowed the former powerhouse considerably. She and Stratton are buried at Greenwood Historic Cemetery, in Birmingham, Michigan, near Perry Stratton's mother and sister, both of whom died in 1914. It is likely the family is buried in Birmingham, Michigan, because Frederick Perry married Harriet Peabody of the prominent Birmingham family. He died in 1918 and is buried there. The Strattons' old friends George and Ellen Scripps Booth and members of their family happen to be buried nearby.

Alexis Lapteff, the sculptor who was like a son to the Strattons, and Florence Barnum, Perry Stratton's companion and nurse during her final years, inherited Perry Stratton's belongings. Henry Caulkins, Horace Caulkins's son who had inherited his mother's stake in the business, also inherited Perry Stratton's shares when she died, becoming the pottery's first sole owner. Mindful of the responsibility to keep the artistic monolith afloat, Henry Caulkins worked to plan its future beyond his sometimes ardent supplementation.

With Perry Stratton gone, her longtime assistant, Ella Peters, by her side since 1938, completed the final installations. Peters had helped

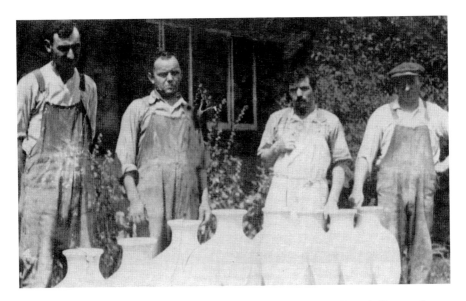

From left to right: Julius Albus, Joseph Ender, John Graziosi and Louis Tomasi. *Courtesy of Pewabic Pottery.*

Perry Stratton considerably during her final decade and stayed on after Perry Stratton's death as Pewabic slowed, its future uncertain as Henry Caulkins searched to determine the best vision for the pottery, most likely as an educational facility. Without any interest from Detroit institutions, Caulkins began talks with Michigan State University. Initially reluctant to take on the responsibility, MSU became more receptive when Caulkins returned to ask again. Soon MSU hatched plans to use the pottery as a satellite for ceramics education. The building closed temporarily for renovations before reopening as an educational facility with office space upstairs where tenants included the Michigan Council for the Arts. By the start of 1967, Pewabic had opened its doors as property of MSU, effectively ending more than a half century's worth of production pottery.

Although MSU successfully kept the building (and so, in large part, Pewabic) intact, pieces of Pewabic's archives supposedly went missing during that era. Murray Douglas wrote about the changes that came when MSU took over ownership:

> *When the Pewabic reopened as part of Michigan State University I was immediately aware that not only were the people gone, but that which reflected them had largely disappeared. Though the redesigned building now*

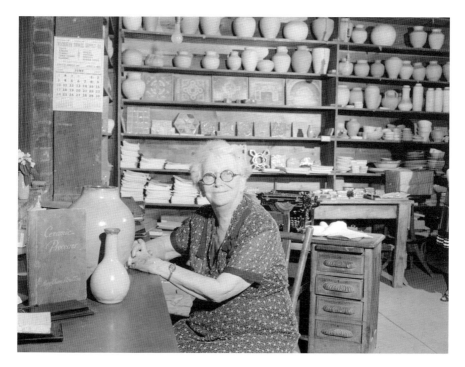

Perry Stratton at ninety at the pottery in 1957. She told *Detroit News* reporter Joy Hackanson Colby, "When you keep busy a half century passes swiftly." *Courtesy of Pewabic Pottery.*

> *has a handsome interior, much more convenient for teaching, I still populate the place with an assorted cast and fill the spaces with tubs of glazes, bins of raw materials, the tunnel kiln that came and went, the dark basement filled with caskets of aging clay, the noises of the gas kilns, the blunger, the gray grinder.*

By the late 1970s, Pewabic's existence again seemed precarious at best. Budget constraints made MSU reconsider its still costly investment. Those who cared about the old pottery knew to start seeking solutions. The university was not opposed.

Among those championing Pewabic's future was Henry Booth, son of George Booth. In a letter dated October 18, 1978, Booth wrote to C.L. Winder, provost of MSU, "in support of maintaining Pewabic Pottery on any practical basis that can be contrived." Booth went on to say that if MSU did not want to continue the pottery, every effort—publicly and privately—to find it a solid future must be considered, "for otherwise

Detroit may lose an important historical 'document' and a cultural and educational asset."

Booth believed that the pottery's future would be best served under the guidance of a nonprofit educational corporation and that resuming tile production could serve restoration projects throughout Detroit, particularly on buildings that carry original Pewabic. With the rising popularity of preservation and restoration, Booth thought it a wise avenue to save the ailing pottery. "Once it is known Pewabic tiles are obtainable, Detroit architects are bound to again think of tile as a beautiful material to use and specify it," wrote Booth, adding that it would also boost Detroit's "reputation as a producer of top quality ceramics."

Booth wrote the letter at the request of Roger Ault, Pewabic's director at the time, and Mary Jane Hock, director of the Detroit Council of the Arts, after MSU initiated steps to close the pottery at the end of fiscal year 1979. Ault was already working on bringing the subsidizing costs down and raising capacity. Booth also wrote a letter to Ault on October 18, 1978, enclosing a copy of his letter to MSU and offering a $5,000 donation in January if it would help, as well as promising another within the year.

On October 12, 1978, MSU released a letter that detailed the letters it had received in support of ensuring Pewabic's preservation and future. Letters arrived from Walter Boris, chairman of the Michigan Council for the Arts; U.S. Senate candidate Carl Levin; Harold Van Dine, director of the Michigan Society of Architects; John Berry, associate of Smith, Hinchman and Grylls; Frederick A. Sargent, president of the Michigan Society of Interior Designers; Ronald S. Steffens, president of the Detroit Convention Bureau; and Erma Henderson, president of the Detroit City Council.

The cost of keeping Pewabic's doors open added up, and greater expenses loomed on the horizon with the building in need of a new roof. MSU decided to postpone closing Pewabic until November 6, noting that Pewabic's founders were important voices in the Detroit Society of Arts and Crafts and the DIA and that Henry Caulkins and at least one of his sisters, Esther Ford, and their families supported saving the pottery, including financially. These efforts, Pewabic's Director Roger Ault explained, demonstrated an overwhelming desire to preserve the cultural landmark.

In 1979, those concerned about Pewabic's future established the nonprofit Pewabic Society as an organized effort to save the pottery, at first by subsidizing MSU's costs to run it. But MSU wanted out, and began working to solidify its replacement to run the historic pottery, says David McKeehan, who at the time was society president and vice-

president of community development with the Greater Detroit Chamber of Commerce and lived nearby.

McKeehan worried that if shuttered, even temporarily, the pottery might never recuperate and Detroit would lose a landmark. Placed in the State Register of Historic Sites in 1970 and the National Register of Historic Places in 1971, it was clear that the building and the pottery meant something on local and national levels. The society raced to secure endowment grants and memberships to prevent what it saw as a potentially fatal blow to the pottery.

"The only option at that point was that they were going to board the place up. It was too valuable a resource to let that happen. It's such a rich part of Detroit's history. The influence of Mary Chase Stratton was national in scope; her influence in ceramic art and architectural pottery is enormous. And it was such a handsome neo-Tudor Arts and Crafts style building," says McKeehan. "It would have been lost forever at that point."

MSU and the Pewabic Society worked together to find another educational institution to run Pewabic but had no luck. In a call to McKeehan, the dean of MSU's continuing education program, which ran Pewabic, commended the group for how well they organized and supported the pottery.

"We've decided that we want to give it to you," McKeehan recalled him saying, adding, "We were sort of like the dogs that caught the car."

The pottery at that time, according to McKeehan, was operating at roughly a $50,000 deficit. The nonprofit group was happy when it could raise $10,000, so it went to work devising a business plan, racing to meet the end of MSU's fiscal hear, June 30, 1981.

In June 1981, the Pewabic Society notified its members that it was successful in demonstrating Pewabic's historic, educational and artistic significance and that efforts to transfer the pottery to the Pewabic Society to assume ownership and management were underway. The Pewabic Society assumed responsibility, and similarly to how smoothly Pewabic changed hands to MSU, MSU returned it to the now two-hundred-member-strong society on September 1, 1981. "There could not be a more congenial nor a more helpful working relationship than exists concerning these important and difficult matters." wrote Raymond Vlasin, dean.

Its years as an MSU entity likely saved the pottery from the irreversible and devastating consequences that felled other enterprises, in particular the thought of losing historic equipment that traces back to the building's earliest days and is still in use today. It didn't come without some cost, though. Historic documents and artifacts from paper ephemera to tile forms to historic pottery disappeared during that period. Murray Douglas noted

that he was surprised at how little material about Perry Stratton existed at the pottery post-MSU, considering he knew of resources there before.

The group determined that Booth's 1978 suggestion to bring back the very heart of Pewabic—production—was a good one, and so it did, retaining an educational studio at the same time. Right off the bat, said McKeehan, the Pewabic Society instituted a strategy to create revenue sources that could sustain the pottery, including establishing a retail gallery. They also worked with MSU to get accreditation for classes, to keep another income stream going.

"We then began to talk about establishing a working pottery for commercial sales of architectural tiles. We still had a bunch of the old molds around," he said, adding that they also sought operating grants to help with funding.

"I actually ended up writing arts grants, which I had never done before. I wrote the grant that converted the attic space into studio space. That was in 1982," he noted, adding that they also created rental space then. "We began to build the board with people who were influential within the arts and the broader community."

They hurriedly secured what remained of Perry Stratton's original collection. McKeehan lamented the loss of artifacts during the MSU administration, including historic pieces from Pewabic's attic, most notably during a 1978 sale.

"Part of our business plan was to have a museum collection," he said. "Everybody wanted to help. It was really a community effort. We had to change the way the place was operated, and so the folks who had become very comfortable during the MSU years were not exactly comfortable. Obviously, change is hard."

An entrepreneurial approach was more important now than ever to sustain Perry Stratton's tone, McKeehan said. Soon word got out, and Pewabic began receiving private commissions. In December 1983, the transition was complete. "Then we got that first large commission with the People Mover," McKeehan said.

In 1986, Mary Chase Perry Stratton was posthumously inducted into the Michigan Women's Hall of Fame for her achievement in the field of art. And in 1991, the Pewabic Pottery building was designated a National Historic Landmark.

With their affection for and dedication to the Detroit Society of the Arts and Crafts, Perry Stratton and Caulkins never intended on Pewabic becoming more than the model of handcrafted art pottery that it was—a nod to the past

and an inspiration moving forward. Now the Pewabic Society would work to rebuild that early momentum that fueled Perry Stratton and Caulkins, with modern-day potters carrying the founders' original intentions of handcrafted ceramic production, education and exhibitions. Pewabic archivist Kimmie Dobos summed up those later years well: "It was good there were people who cared enough to keep it going. And it was good there were people who cared enough to take it back."

PEWABIC TODAY

CONTINUING THE HANDCRAFTED MISSION

"Pewabic enriches the human spirit through clay."

In a 1946 journal article, Mary Chase Perry Stratton wrote that Pewabic Pottery began in the "spirit of work and play" and that "the growth of Pewabic Pottery has been so unlike that of more experienced places that some of the high spots may interest, if not amuse, our more conventional contemporaries."

More than a century since its inception, Pewabic does not just remain—it thrives, operating on a budget that surpasses $3 million in 2016. That spirit is still intact in the pottery's careful balance of creating art and being a business. Whether it's an employee in the historic building's second-floor offices finalizing an agreement for a large-scale installation or a tile presser getting a head start on one of the pottery's annual snowflake ornaments, the nonprofit puts into practice its modern motto, "Pewabic enriches the human spirit through clay." It rings true everywhere from a backsplash set to go in a private home to studio space the pottery provides its employees to work on their own pottery projects.

"There's a caterpillar hidden there," explained David McGee, senior designer, gesturing toward an almost four-foot-radius paper circle filled with more than a dozen animals nestled together. The captivating design demands exploration, holding an onlooker's attention to spot the different animals—a kangaroo, an elephant, a giraffe, a squirrel—curled together like puzzle pieces perfectly intact. McGee designed the commission for the St.

John Hospital Birthing Center to amuse, calm and distract, children eagerly awaiting a sibling's arrival. For McGee, it's all in a day's work.

"Where else can you go to work every day and you make something meaningful," McGee said with a smile. "Pewabic was here before it was cool to be in Detroit. With the whole longevity of Detroit that we've seen, all the manufacturing in Detroit, we were here first. Now we're stronger than we've ever been."

As McGee's paper design translates to clay, it becomes a three-dimensional hand-molded and hand-colored art piece. This multistep process is no easy task. It requires careful consideration to ensure that thick and thin areas dry at a similar rate to avoid any weak spots that may be inherently liable to crack. The person in charge of transforming the clay via pottery plaster molds is fabrication supervisor Sherlyn Hunter. She and her staff press Pewabic's many tiles, but something this tricky and time-intensive she often tackles herself. Hunter likes the challenge. "This is the fun stuff. It's the hard stuff *and* it's the fun stuff," she said. "I always say the clay is in charge. You do what it needs to do. You learn what it requires."

Hunter works tucked away in a space lined with shelves holding somewhere around 435 ornament or master molds alone—the entire pressing area has more than 2,100—tightly stacked in every nook and cranny, which is how Hunter earned her nickname, "Squirrel." These aren't all of Pewabic's molds, just the ones the fabrication department used most recently or may need to in the near future.

Hunter started at Pewabic as a Detroit Public School student in the mid-1980s in the pottery's early post-MSU days, when it was working itself back to being a production pottery. She began as a presser and quickly learned all of fabrication's roles—processing, glazing, kiln firing, you name it. "We were figuring it out. How do you press tiles? How did Mary press tiles? We were learning the equipment and creating our mallets, our wires, and learning how the foot press works," said Hunter, describing the soap press Perry Stratton converted to press tiles. "She had dies for all kinds of tiles. The 3x3 that we use now comes from that same original die from the foot press, we just use a ram press. Even though we changed the game, it's still the same tile."

Initially, Pewabic staff pressed field tiles one at a time, explained Hunter. Now the larger ram press allows nine three-by-three tiles at once, six four-by-fours at a time and four six-by-sixes at a time. It's all still handmade, retaining the curved edges that mattered most to Perry Stratton, but it's not quite so labor and time intensive. "All of that is still hand-touched," she explained,

pointing out how edges need to be smoothed. "It's still very handmade, even though there's a thirty-ton press involved in the process."

From clay preparation to inspecting the product before it heads to its bisque firing, shortcuts don't exist. "How we prep clay is really important in how we get a successful tile," Hunter said. "If you're not prepping the clay, you're just making bad tiles fast. You have to recognize what to do. Clay has memory."

Without any manuals to guide them, rebuilding Pewabic's production took figuring out how Perry Stratton worked the clay body and mixed the glazes. Like with Perry Stratton, it often comes together through a process of trial and error, with determining factors that can change depending on the season and how much humidity is in the air. "Even [with] our pugmills," said Hunter, referencing the clay-making machinery, "there was no written information on how to use it. It changes its own conditions."

That's part of Pewabic's history, noted Hunter, who believes it's important to take note of and appreciate what came before. She considers herself the biggest fighter for the history but added that the product today is more pristine than it was in Perry Stratton's time, in large part because that's what the customer wants. When the pottery decides to reintroduce a historic tile, Hunter is careful not to fix any perceived flaws when replicating the old mold into a new one for production to use. "I'm a perfectionist. Mary was nowhere near a perfectionist, but I can present my perfectionism in preserving her quirkiness," Hunter said with a smile. "I'm not here to correct what she did. I'm here to preserve and continue what she did. That's my part of staying true to her. If we stand on this historic soapbox, that's what she was all about. I get innovation, but you don't do it in the process of what she was all about."

As for those historic molds, Hunter said that some in storage date back to the 1930s, but throughout the years many disappeared, some destroyed by neglect or because of their age and some simply went missing—thrown away or fell into private hands—during the leaner, unguarded years after Perry Stratton's death. Fortunately, Pewabic's archives does have some. With no gauges and dials, using the molds is very manual and requires getting to know the mold and the design to get it to work just right, Hunter said. "That's what we are. We're a handmade joint."

Where Hunter is on the early end of the process, glaze development specialist Alex Thullen completes the part of the process that Perry Stratton most enjoyed. Naturally, he often fields the questions—actually, everyone

does—about Perry Stratton's glaze book and the rumors that gravitate around it, namely that she took her recipes to the grave.

"It's a myth," said Thullen, who started at Pewabic in 2005. "We've been told by a person that he has notebooks with the recipes so they exist in private hands as well."

Archivist Kimmie Dobos reiterated the "glaze book to the grave" myth. Only a select few know the secrets, she explained, because Perry Stratton did want ceramicists to create their own recipes rather than being dependent on hers.

"It was her intention to never publish those recipes, to keep them private. You want to keep a little bit of the mystique. I don't talk about specific materials," said Thullen, who remains protective of Perry Stratton's wishes not to reveal too much and pointed out that Perry Stratton always encouraged potters to come up with their own processes. "I have to wonder if she thought that handing information off to someone would be doing them a disservice from an educational standpoint. That has always been my attitude toward it. That was her life—her trademark—that was what put her on the map. She wanted to encourage people to experience it for themselves."

Although the recipe book is interesting historically, many variables have changed since Perry Stratton's time, and today's Pewabic uses safer materials and practices that weren't available then. Perry Stratton's glazes were lead-based, which was not the worst material she used considering some glazes contained uranium, said Thullen. Plus the composition of materials changes over time, meaning recipes continually have to be reformulated to keep them consistent. In many cases, noted Thullen, Perry Stratton often created her own materials by fritting, a process of melting ingredients together in a crucible and then grinding down the hardened results to make a glaze compound. It enables greater consistency between batches, and Perry Stratton could add colorants to achieve the look she wanted. And with technology and higher firing temperatures comes greater functionality, as opposed to Perry Stratton's porous earthenware. Materials would likely burn out.

"We've crafted a palette that mimics what she created historically with the technology and techniques available today and that are safe for us to use," explained Thullen, adding that they know how to capture Pewabic's original rich, luscious surfaces. "There's a warmth to it, the saturated colors, the really beautiful matte surfaces that we try to replicate without using lead. We try to reference that feeling."

Today, Pewabic utilizes more than six hundred glaze variations, although not such a large number on a regular basis. Pewabic's giftware palette consists

of fewer than twenty colors and the design team uses a standard palette of about seventy for its architectural orders.

Bridging that palpable history in the building is a big part of what makes Pewabic special to Thullen and to others connected with the pottery, either as employees or customers.

"There's really nowhere else you can go that does all the things we do. There's an extraordinary amount of potential," he said. "For me, I've learned so much since I've come here. It's really informed my studio practice in a significant way to be working in and carrying on her traditions."

What Thullen is to Perry Stratton, Neil Laperriere and Chris Mayse are to Pewabic's other founder, Horace Caulkins: They control all things kiln-related. Although Pewabic still uses the original clay-making equipment, the production kilns today are more efficient and produce less pollution. The building's towering chimney, so vital when the building went up, is no longer necessary, thanks to modernized venting methods. Restored in 2008, it still stands as a beacon.

"Most of our firings for an oxidation firing, which is generally what you see at the gallery store, goes just above 2200 degrees to 2260 depending on what kiln it goes in. There are a few firings that go a little bit hotter. Our hottest firing just crosses over 2300 degrees, to about 2310 Fahrenheit, and that's the really saturated copper red that you see around the holidays," explained Laperriere, adding that today's modern gas-fired kilns are electronically controlled.

Given the unpredictable nature of firings, Laperriere and Mayse conduct a multi-point check of products, inspecting for cracks or debris. They also lay out installations such as fireplace facings and backsplashes to ensure that all the dimensions are correct and the tiles fit as planned, as up until that point designers and customers have only worked with glaze palettes and a two-dimensional schematic.

Being part of Pewabic means being part of "a codified historical organization," Laperriere said.

"Pewabic means so many things to this city," added Laperriere, pointing out the importance of carrying out the work of somebody who started a statement business at a time when she wasn't even allowed to vote. "She's doing what she wants and making beautiful artwork and being taken seriously."

With anything as historic as Pewabic, legends, rumors and ghost stories are bound to become part of the narrative. Some people believe that Perry Stratton's presence remains, indelibly part of the fabric of her building.

Throughout the years some say that they have sensed her nearby, while others say they heard sounds they swear must be her. Others insist she keeps watch through a small door she installed in her second-floor studio to overlook the kiln room.

Archivist Dobos hears more rumors and misconceptions than the ghost stories. A frequent one is the assumption that Perry Stratton did everything, almost negating the existence of Caulkins and employees.

"It started out as a true partnership between Mary and Horace Caulkins. And she had a team of people backing up her efforts behind beautifying the city," said Dobos, who also occasionally fields questions that Perry Stratton hired children to install the tiny, intricate mosaics. Dobos hasn't found anything on-site to corroborate that, although Perry Stratton did hire women in part because she thought they had nimble fingers and patience, Dobos explained.

Perry Stratton also did not smash all her molds before she died, a rumor Alethea Davenport, education events coordinator, hears. "We have historic molds, so that's not real," she explained.

What is real is the apparition-like Jesus outline on the floor of Pewabic's second-floor education studio space, where Perry Stratton would lay out installations. That was where she did the cutout around the Jesus figure that was headed to the National Shrine in D.C. At first glance, the marks on the floor look more like cracks. "Just knowing it's here makes me smile. I like that pieces of history remain part of the building," said Davenport—especially, she added, because it connects the pottery to work across the country. "She did what she had to do in order to have a successful business at a time when women didn't own businesses. She was determined to be successful."

That steadfast dedication, and the feeling of rebirth that connects Pewabic's earliest days with its work today, reverberates throughout the pottery building, where employees and visitors share a sense of pride in the business, its history and the city.

"Detroit has gone through so much turmoil through so many years, yet this building is still basically like it was one hundred years ago," said Hal Wilkes, Pewabic's logistics coordinator. "It's like a little island, right in the middle of everything."

Around the holidays, Wilkes sends out almost one hundred shipments per day. "That's pretty good for a little tiny company," he said. "I think we're doing well. Maybe it'll stick around one hundred more years."

Although a portrait of Perry Stratton overlooks his desk, Executive Director Steve McBride is the first to point out that Pewabic is not a shrine

to its founder. "She was a remarkable woman and represents a rich part of our history, but the pottery did not end in 1961. Our history is also the People Mover stations and Comerica Park and the tile for St. John's Birthing Center. To me, what's exciting is how can we be part of the future: This amazing renaissance that is Detroit today," said McBride.

Chances are that Perry Stratton would approve of the state of Pewabic today. First and foremost, the company to which she dedicated her life, that she traded her dream house to keep going, continues to be one of handcrafted—not mass-produced—pottery. And just as it still expounds that Arts and Crafts movement mission of making utilitarian objects in life also beautiful handcrafted art, it also evolves elements of the business Perry Stratton expounded when she was on site there for half a century. With its rich legacy of providing art and art education in the city, Pewabic is in a unique position to connect Detroit's past, present and future. "One of the things that sets us apart from almost any other arts organization in the country is the physical connection with the city. We are literally a part of the cultural and physical fabric of the city and of the region," McBride explained. "In many ways we're positioned right now to come full circle, with Detroit being in a process of revitalization and renaissance. So is Pewabic."

Pewabic's 2016 budget was more than $3 million between custom architectural tile and giftware production, education and support from grants, memberships and donations. An active participant in what many consider the modern-day rebirth of Detroit, Pewabic is slated to complete new work around the corner, including installations in the city's new hockey and basketball arena and the M1 Rail/QLine Stations that will link downtown and midtown Detroit. Pewabic also aims to become integrated into the city through public art installations. "This is a city that loves the arts, that recognizes the power of art," McBride said. "We've been exploring opportunities to create new work, publicly available art, whether it's murals or fountains or tile installations, where we can be part of the whole zeitgeist of the city."

And as Detroit grows, so does Pewabic, which announced plans in early 2017 to raise funds to build a 2,500-square-foot tile studio addition behind the historic building to improve working conditions and workflow and increase handmade production of tiles. Pewabic plans to maintain the historic character of the original building and retain Perry Stratton's dedication to eschewing industrialization.

Pewabic also hopes to expand its educational initiatives to become more connected with local schools, particularly those within a square mile of

its Jefferson Avenue location. In 2016, Pewabic instructed roughly 2,500 adults and 9,000 youth in classes, hands-on workshops and outreach programs; through grants and other opportunities, it envisions being able to set in place artists-in-residence in nearby schools like Southeastern High School, which already has a kiln and kiln room in an art space cordoned off years ago, left abandoned by programming cuts. Having Pewabic in its backyard should be a source of pride and could even help the neighborhood become a new creative corridor, McBride said. "To me it kind of encapsulates some of what's happened in Detroit. There was a lot of beautiful investment," he said, adding that Southeastern even has a 1931 Pewabic drinking fountain. The school has less than a quarter of the students it was built to serve, noted McBride.

Such evolution is necessary to remain viable, and no one would understand that more than Perry Stratton, who reinvented Pewabic multiple times. Today, that evolution includes new giftware Pewabic makes—the Pewabic pint, rocks glasses and the new Postcards from Detroit tiles—all of which tap into the energy of the city and the sense of a return to an appreciation of

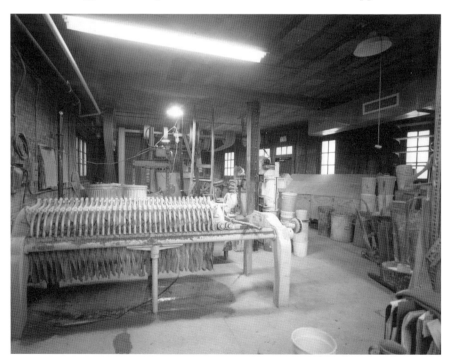

Production clay-making equipment became part of Pewabic Pottery when the back portion of the original building was added in 1912. *Courtesy of Pewabic Pottery.*

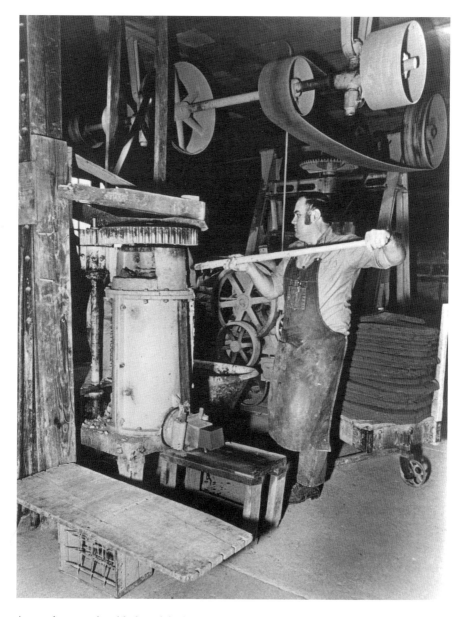

An employee works with the original pug mill at Pewabic Pottery, circa 1975–85. *Courtesy of Pewabic Pottery.*

craftsmanship and handcrafted products, said McBride, much like Pewabic's earliest days in an era eager to celebrate the Arts and Crafts. "People are looking for a little bit more of that authentic craftsmanship," he said. "There's something powerful about that daily interaction with the small-scale pieces that we do in addition to the large-scale installations."

And the history is there, still carrying through the heart and soul of the pottery, which largely remains the same, with modern equivalents when necessary. The glazes can't be precisely the same as in Perry Stratton's day because some of the materials aren't safe enough or readily available and also react differently in modern-day kilns, but they're pretty close. And Pewabic still uses the same clay-making equipment as what was installed when the initial addition was built to the original building. "That's what's so unique about Pewabic. Our clay mixer dates to 1912. It was built into the building, and we still use it to make our contemporary work," McBride said. "You come in here and you see people using the same clay-making equipment that Joseph Ender used. There's something magical about that."

The filter press clay-making machine thoroughly mixes a liquid slip and then presses the water out to create a great clay consistency. The time-consuming method is rarely used in today's pottery business, noted McBride, adding that Greenfield Village has a filter press that is actually younger than Pewabic's.

It's that vibe of authentic makers crafting one-of-a-kind pottery pieces that sets Pewabic apart. It can take months of lead-time, but in the end, it's worth it because you can feel the craftsmanship from the people who've handled it—from the clay throwers or pressers to the glazers and the people who do the firing, the hands who've cared for it on its way to the recipient. "I really want that whole journey to feel special," said McBride.

SELECTED PEWABIC DETROIT INSTALLATIONS

"In Detroit, life is worth living."

The saying on the circa 1910 tile made for the Detroit Board of Commerce—"In Detroit, life is worth living"—became a proud slogan for the city. Like Detroit, Pewabic was bustling. With architectural tiles on the rise, Pewabic installations would soon appear in the homes of wealthy industrialists and automotive barons, as well as in and on public and private buildings throughout Detroit's towering "Cathedral of Finance," the Guardian Building. Pewabic averaged two large-scale installation projects at a time while keeping up with smaller-scale architectural orders and giftware.

Tallying a complete and accurate count of where Pewabic installations remain is impossible—in part because records are incomplete but even more because structures change on a daily basis, and many aren't open to the public. The following is a list of publicly accessible Detroit installations still in existence. It does not include locations mentioned elsewhere in the book or the many Metro Detroit churches that may also be open to the public, notably Holy Redeemer.

PEWABIC POTTERY (1907)
10125 EAST JEFFERSON AVENUE, DETROIT

No place offers a greater essence of Pewabic than to visit the pottery itself. Designed by W.B. Stratton and built in 1907, Pewabic today uses every inch of the original building, plus several additions, a neighboring building and an offsite vessel-throwing studio. Although Pewabic still eschews modern mass production, the Pewabic Society board recognizes the need to expand and upgrade and is in the planning process of adding a new on-campus state-of-the-art tile pressing facility to better meet production needs and improve the working conditions for pressers.

"This building was built to be one purpose. It's never been anything else. It still amazes me that people don't know we're here. It's a different time now too. It took six years to build a church. Now everyone wants their tiles two weeks ago," pointed out David McGee, senior designer.

DETROIT PUBLIC LIBRARY (1921 AND 1926)
5201 WOODWARD AVENUE, DETROIT

What may be Perry Stratton's most extraordinary work in a Detroit public space may also be one of the least known because of its hard-to-reach (and see) location.

In 1918, architect Cass Gilbert commissioned Pewabic to furnish mosaics for his Italian Renaissance–style Detroit Public Library building. The Main Library includes a loggia ceiling tucked inside the Woodward Avenue Vermont marble and serpentine Italian marble façade. Except on rare occasions, the space is only accessible and visible from the library's second-floor Fine Arts Room.

Based on drawings by Frederick Wiley, each barrel vault and arch depicts Shakespeare's "Seven Ages of Man"—infancy to decrepitude—from Act 2, Scene 7 of *As You Like It*. Wiley simplified his initial drawings to allow Perry Stratton to translate it into mosaic form. She wrote that she was lucky that the ceiling structure wasn't yet in place, so the pottery could reproduce the curves to better understand how best to fit the intricate mosaics into the marble vaults and arches:

This made the whole operation much simpler, enabling us to bed the tesserae patterns on a table instead of the arduous strain of working overhead, and

allowed me to take some considerable part in it. It was quite a trick to bring out the small figures, and the gold letters with the text so they would be legible from the floor, and yet would not be too sharp as a whole decoration.

Completed in 1921, the results are majestic.

In 1926, Pewabic also designed and made the Storybook Fireplace frieze in the children's library, depicting familiar tales or legends, including *A Midsummer Night's Dream, Alice in Wonderland* and *Mowgli and the Bear*, among others. The incised tiles of varying colors range from brilliantly bright to subdued unglazed colored clay, set within a border of iridescent tiles. Alexis Lapteff, the young man who was like a son to the Strattons, designed the tiles. The children's library relocated into the 1963 wing, but the Storybook Fireplace remains.

Around the time they completed the loggia work, Gilbert and Perry Stratton also began plans for the James Scott Memorial Fountain on Belle Isle. Perry Stratton wrote Gilbert a letter on December 26, 1921, telling him, "We have an idea of using about two and a half feet of solid tile on the edge, working into a wave pattern, in which are sea horses, starfish (perhaps crabs), which break into areas of concrete—and bubbles leading from the fish forms running toward the centre about six feet from the edge, about to the bronze turtles."

The colors, she wrote, would "be very bright and various at the outer edge working into mid blues and greens. We have a wonderful new blue!" Pewabic, she felt, "could do this for the stipulated sum $5,000."

Gilbert responded on December 30, 1921, that the "use of brilliant blues and greens is in line" with what he was thinking and that he was "very glad that you are taking such a strong personal interest in the matter."

Pewabic's mosaic loggia at Detroit Public Library's Main Library, 1918. *Courtesy of Pewabic Pottery.*

That March, with the fountain work progressing, Perry Stratton wrote to Gilbert that she "had the pleasure of climbing over the Scott Fountain structure…and gained quite an impression of importance in the landscape." She called the scale immense yet did not sound daunted by it: "The border of colored tile would be seen across the pool, and the areas would have to be the same size to be apparent and also decided in color and contrasts—which would give a tone to the moving water, as well as magnifying the design into colored reflections."

The fountain would feature the blues and blue greens Gilbert so liked, with seahorses in yellows and orange and fish and crab forms in light green, along with other elements in varying colors and an all-over fish scale for background. Perry Stratton told Gilbert that within the last month they used something similar on a smaller scale in a pool at their own house, "and it gives the most shimmering and aquatic effect imaginable."

Sadly, the Pewabic tile that bordered the fountain basin fell into disrepair, and the city dismantled it in the early 2000s. The Belle Isle Conservancy has its eye on restoring the fountain, with Pewabic re-creating its majestic design.

DETROIT INSTITUTE OF ARTS (1926–27)
5200 WOODWARD AVENUE, DETROIT

"Then came fountains, alcoves and risers for stairs in the Detroit Institute of Arts, which I like to feel is a lasting record of the Pewabic Pottery," wrote Perry Stratton of work the Detroit Institute of Arts commissioned.

Being a physical, permanent piece of Detroit's artistic landscape in a building fully dedicated to art resonated with Perry Stratton. Pewabic's presence is notable throughout the building. Near the main entrance to the American Art galleries, iridescent Pewabic tiles make up two ten-foot-tall niches and the basket mosaic medallions installed above them. Although part of the original building, which opened in 1927, the niches were covered around 1960, only to be rediscovered and restored during DIA renovations in 2007. Nearby, a drinking fountain with a Pewabic tile background adorns the vestibule that links the DIA's Great Hall and Rivera Court.

The DIA work cost $4,864 for the niches and two drinking fountains (the other is in the theater promenade), as well as the fifty-six risers for the stairs in the theater. Pewabic created a more recent tan and blue tile

floor central installation in the late 1980s to accommodate Rivera Court renovations.

The DIA held special meaning to Perry Stratton. She had long found inspiration from Benjamin March, the DIA's curator of Asiatic art, from 1927 to 1931 as the pair traded March's vast knowledge of early Chinese ceramics with Perry Stratton's understanding of modern ceramic practices. "In order to verify these theories he spent one day a week demonstrating in our workshop certain deductions. Whether or not proof was brought to any of these queries, the time was unforgettable with his brilliance of mind and quick scientific summaries," wrote Perry Stratton, who always appreciated opportunities to learn from others.

Such intellectual interaction, said Perry Stratton, was "to keep one on his ceramic toes, ever looking forward to another and another unfoldment, harking back to the past, yet beckoning into the future."

During March's time as curator and a University of Michigan professor, he worked closely with Perry Stratton to develop expansive and combined public programs. March and Perry Stratton's collaboration worked well and included a laundry list of activities, including exhibitions in the front windows of local retail spaces and demonstrations that almost anticipated later twentieth-century exhibitions that incorporate public programs, showing how Pewabic was intrinsic to those DIA's exhibitions.

Furthering the connection between the two organizations, Lang and others donated Pewabic pieces to the museum, and in 1947, Perry Stratton donated a collection of her late husband's architectural drawings and photographs—including those of their own Three Mile Drive residence, the Caulkins residence, the Naval Armory and the Women's City Club—to be part of the museum's permanent collection.

THE GUARDIAN BUILDING (1928–29)
500 GRISWOLD STREET, DETROIT

When Pewabic made the transition from creating church embellishments to making tiles destined to be part of Detroit's "Cathedral of Finance," the proposed Union Trust Company skyscraper, Perry Stratton described it as switching gears.

"Our real 'commercial job' was the multicolored faience in modern design in the window sills, aprons, and entrances in the Union Guardian Building. This taxed our capacity to the utmost, but our deliveries were on the minute," wrote Perry Stratton.

Chief architect Wirt C. Rowland of Smith, Hinchman and Grylls meticulously designed the thirty-six-story structure that included the work of an unparalleled assortment of artisans, mosaicists, sculptors, painters and tile manufacturers. Pewabic's part of Rowland's art-filled Art Deco building was to fill the arches, jambs, sills and aprons of the windows with a bright, almost Aztec-looking tile pattern in the large domed window openings, including a stylized figure with outspread wings meant to represent progress.

"The great half-dome over the main entrance, with its symbolic figure of an aviator surmounting the globe was so enormous that it could not be erected under our roof—none of our rooms had dimensions to contain it," wrote Perry Stratton, who worked closely with the actively involved Rowland.

Pewabic constructed a giant plaster frame in the pottery building's front yard to map out the design. Later, once all the terra-cotta tiles and other pieces were fired, workers again spread them onto the mold for numbering to guide the tile-setters during the installation process. Perry Stratton described the many shapes, all "properly glazed in brilliant colors," as resembling an exaggerated jigsaw puzzle.

Above the Congress Street entrance, a beehive symbolizes thrift, an eagle money and a caduceus authority and commerce in a repeated pattern. "This whole adventure into Big Business taxed our small establishment quite to its limit, and we all felt the strain as a family," Perry Stratton recalled.

In the end, Perry Stratton's daybooks note that Pewabic tile installations at what finally was called the Guardian Building totaled $14,985.30 in 1928. At the building's completion in 1929, the Guardian Detroit Union Group was Detroit's largest financial establishment. The stock market crash later that year ended not only Union Trust's prosperity but also much of Detroit's. Before long, the bank's owner was bankrupt, like so many others.

Often mistaken for Pewabic, the tiles on the interior are by Cincinnati-based Rookwood Pottery, which ultimately closed in 1967. Pewabic reproduced 1,500 of those damaged tiles during 1985 renovations to restore the vaulted lobby, which had been dramatically altered in the 1950s.

THE SCARAB CLUB EMBLEM (1928)
217 FARNSWORTH STREET, DETROIT

William Buck Stratton designed the glazed colored terra-cotta Pewabic scarab that looms high above the Scarab Club's main entrance. Sculptor Horace F. Colby modeled it.

DETROIT PEOPLE MOVER STATIONS (1986–87)
TIME SQUARE STATION, MICHIGAN AVENUE STATION, MILLENDER CENTER STATION AND CADILLAC CENTER STATION

In the early 1980s, public art advocate Irene Walt embarked on a mission to incorporate art installations into each of the thirteen Detroit People Mover Stations on the city's almost three-mile elevated monorail transit system. Because of its durability, ceramic tile decidedly became a favorite medium for the project. Pewabic artists created three pieces, and the pottery produced tile for an additional four.

The Times Square Station at Grand River Avenue features artist Tom Phardel's contemporary Pewabic tile installation *In Honor of W. Hawkins Ferry*, named after the second-generation Detroit architect and longtime arts patron who was a member of the Art in the Stations Commission. Phardel, chair of the ceramics program at the College for Creative Study and an instructor at Pewabic, used almost one thousand square feet of brightly colored Pewabic tiles to create a bold Art Deco–inspired design to honor Ferry, who died in January 1988.

The Times Square Station also includes Anat Shiftan's *Art in the Stations* tribute, which features Pewabic's commemorative logo tile of the same name that guests received at the piece's official opening in 1987. Shiftan was Pewabic's chief designer at the time. The logo design was by Larry Ebel.

Allie McGhee created *Voyage* at the Michigan Avenue Station. A painter, McGhee had to learn the glazing process and meticulously taped off tiles to create the effect he wanted. He brought six hundred tiles back and forth from his studio to Pewabic to be fired in the kilns.

At the Millender Center Station, Detroit native Alvin Loving Jr. created *Detroit New Morning*, a sweeping swath of colorful pastels and iridescent tiles that make up two murals meant to represent rain, lightning, rainbows, silver-lined clouds and sunrise. Like McGhee, the noted abstract painter, whose work is part of the permanent collections of the DIA and the Metropolitan Museum of Art in New York, among others, was not a ceramicist, so he had to become more familiar with the medium. The installation culminated in five thousand tiles.

Pewabic fabrication supervisor Sherlyn Hunter recalled that because of the installation's considerable size and Loving's abstract painting style, Pewabic employees at one point rolled a glaze technician wearing roller skates alongside the temporarily arranged piece to incorporate Loving's smooth strokes of colorful glazes.

"Each and every one of those tiles was touched seventeen to twenty times," said Hunter, reminding of how handcrafted the tiles are from pressing to glazing to reglazing and installation. "We just kept pressing."

The People Mover's Cadillac Center Station features *In Honor of Mary Chase Stratton*, a 21- by 150-foot art installation designed by Diana Pancioli, an Eastern Michigan University ceramics professor and Pewabic employee at the time. The two-story, multi-wall installation incorporates historic green field tiles donated by the Stroh family, who originally commissioned the tiles for brewery use as early as 1935 and as late as 1955.

Pancioli intermingled new and historic field tiles, as well as new Pewabic tiles made from 1926 "career" molds that depict Detroit's workforce. The historic molds originally made tiles that decorated Detroit's Northern High School.

Pancioli had to make some larger matching tiles to accompany the original Stroh tiles to complete what is the largest of the station installations. To do so, she had to create a modern-day equivalent of the glaze color. Fortunately, Perry Stratton had given the Stroh company the original recipe, which the Stroh archives had. Remaining Stroh tiles become the backgrop to Marshall Frederick's bronze sculpture *Siberian Ram* at the Renaissance Center Station. Pancioli also used them in other Detroit installations she designed, including "Passage" at Compuware Corp. headquarters in November 2003 and "Arc" in 1996 at Detroit Receiving Hospital and University Health Care.

M1/QLINE STATIONS (2017)

More utilitarian in design than the art installations at the People Mover Stations, Detroit's dozen Qline streetcar stations also incorporate Pewabic tile. Designed by Detroit-based architectural firm Rossetti, the glass and concrete stations each include two wall-facings of Pewabic tile in the color station sponsors requested.

Incidentally, Detroit isn't the only place where Pewabic adorns mass transit stations. The Thirty-Fourth Street Herald Square subway station of New York City's Metropolitan Transportation Authority features "Radiant Site," by Michele Oka Doner. Created in 1991, the permanent installation features eleven thousand bronze iridescent Pewabic tiles that Doner made individually using Perry Stratton's old foot-press.

WAYNE STATE UNIVERSITY
BONSTELLE THEATRE (1902), OLD MAIN (1927–28,1998) AND
DAVID ADAMANY UNDERGRADUATE LIBRARY (1998)

Wayne State University includes multiple Pewabic installations, although not all are clearly open to the public. Built in 1902 as the Temple Beth-El, the Bonstelle Theatre at 3424 Woodward Avenue features Pewabic tiles in its entryway.

The Millender Center People Mover Station wasn't the only collaboration artist Al Loving had with Pewabic. Loving also created the tile mosaic *Life, Growth, Continuity*, installed in 1998 in Wayne State University's David Adamany Undergraduate Library, named in honor of the university's former president. Somewhat less public than other installations listed here, the mural-sized piece sits just within the library's main entryway on campus. The university prefers that visitors check in with library personnel when they enter the building.

Also on Wayne State's campus, a disconnected Pewabic drinking fountain remains on a wall on the second floor of the historic Old Main building, formerly Detroit Central High School.

The Freer House, part of Wayne State University, has two Pewabic fireplaces. The space operates as the Merril Palmer Institute, and it isn't regularly open to the public.

COMERICA PARK (2000)
2100 WOODWARD AVENUE, DETROIT

With an exterior that features 462 eight-inch half-circle baseballs, a host of Tigers Old English "D" logo twelve-by-twelve embossed tiles and fifteen-by-twelve medallions and almost 300 pieces Tiger stripe trim pieces, plus an oversized tiger medallion, Pewabic is a large part of Comerica Park.

NORTHWEST MIDFIELD TERMINAL, WAYNE COUNTY
METROPOLITAN AIRPORT (2001)

Notice the forty thousand silver Palladian-finish tiles near the bathroom entrances. Those are Pewabic. Their dual finish makes them particularly suitable for such a high-traffic public space but also suggest an appearance

and a reflective nod to Detroit's automotive industry legacy by subtly resembling chrome. "The hope was that the terminal would reflect the city, our history and the automotive industry," explained designer Genevieve Sylvia.

DETROIT ZOO (1929)

Although technically outside the city, the Detroit Zoo features Mary Chase Perry Stratton's peacock medallion installation inside its Wildlife Interpretive Gallery.

BIBLIOGRAPHY

Selected Books and Journals

Andrews, Wayne. *Architecture in Michigan.* Detroit, MI: Wayne State University Press, 1967.

Ault, Roger. *The Collector Looks at Detroit…: Its History, Its Historical Museums, Its Detroit Silver, Its Pewabic Pottery, Its Detroit Chair Company.* Ann Arbor: University of Michigan, 1973.

Baraga, Frederic. *A Dictionary of the Ojibway Language.* Reprint, St. Paul, MN: St. Paul, Minnesota Historical Society Press, 1992. Originally published in 1878.

Bleigher, Fred, William C. Hu and Marjorie Uren. *Highlights of Pewabic Pottery Adapted from the Comprehensive Survey of the History of the "Pewabic Pottery: Pewabic Pottery: An Official History."* Ann Arbor: Michigan State University and Ars Ceramica Ltd., 1977.

Carney, Margaret, Charles Fergus Binns, Paul Evans, Susan R. Strong and Richard Zakin. *Charles Fergus Binns: The Father of American Studio Ceramics.* Manchester, VT: Hudson Hills Press, 1998.

Eckert, Kathryn Bishop. *The Campus Guide: Cranbrook.* New York: Princeton Architectural Press, 2001.

Kingsley, April, and Thomas W. Brunk. *Pewabic: A Century of Michigan's Art Pottery.* Exhibition catalogue, 2005.

Miller, Page Putnam. *Landmarks of American Women's History.* New York: Oxford University Press Inc., 2003.

Nawrocki, Alan. *Art in Detroit Public Places.* Detroit, MI: Wayne State University Press, 2008.

Nelson, Marion John. *Art Pottery of the Midwest.* Minneapolis: University of Minnesota, 1988.

Pear, Lillian Myers. *The Pewabic Pottery: A History of Its Products and Its People.* Wallace–Des Moines, IA: Homestead Book Company, 1976.

St. Paul's Cathedral. *St. Paul's Cathedral Detroit, Michigan: One Hundred Years, 1824–1924.* Detroit, MI: St. Paul's Cathedral, n.d.

Stratton, Mary Chase Perry. "Adventures in Ceramics: The Story of Mary Chase Perry and the Pewabic Pottery." Unpublished, n.d.

———. *Ceramic Processes.* Ann Arbor, MI: Edwards Brothers Inc., 1941, 1946.

Walt, Irene, and Balthazar Korab. *Art in the Stations: The Detroit People Mover.* Huntington Wood, MI: Art in the Stations, 2004.

Witkopp, Gregory, and Stefanie Dlugosz-Acton. *Simple Forms, Stunning Glazes: The Gerald W. McNeely Collection of Pewabic Pottery.* Bloomfield Hills, MI: Cranbrook Center for Collections and Research, 2016.

Selected Magazine and Newspaper Articles

American Magazine of Art 9, no. 9. "Ninth Annual Convention the American Federation of Arts: Detroit, Mich. May 23–24, 1918" (July 1918).

Avery, Marjorie. "Woman of the Week: She Created a New Glaze." *Detroit Free Press*, Sunday Graphic, January 12, 1941.

Cohen, Daniel. "Modern Mosaic." *Historic Preservation* (March–April 1990): 30–35, 78.

Colby, Joy Hackanson. "Mary Chase Stratton at 90 Keeps Pewabic Kilns Busy." *Detroit News*, 1957.

———. "Pewabic in Perspective: Pottery's Place in History." *Detroit News*, March 25, 1979.

Davies, Florence. "An Ancient Art Persists: Famous Pewabic Pottery Busy with Students Learning Ancient Art." *Detroit News*, August 26, 1934.

———. "Artists Honor Mrs. Stratton." *Detroit News*, December 1, 1932.

———. "Things that Last." *Detroit News*, October 9, 1932.

Detroit Free Press. William Buck Stratton obituary, May 14, 1938.

———. "Pewabic Develops New Light Glazes." December 8, 1940, 7.

Detroit News. "Pewabic Tiles to Decorate Crypt of Beautiful Shrine in Washington." April 19, 1925. Reprinted in *Salve Regina* (June 1925): 43–48.

Garwood, Dorothy. "Mary Chase Stratton" *Ceramics Monthly* (September 1983).

Keramic Studio. "Louisiana Purchase Exposition Ceramics" (February 1905).

Novak, Celeste. "Pewabic: A Vehicle for Symbolism of the Arts and Crafts Movement." *Chronicle* 21, no. 3 (Autumn 1985). Quarterly Magazine of the Historical Society of Michigan.

O'Brien, Bertha V. "Mary Chase Perry's Moment of Triumph." *Detroit Free Press*, April 18, 1909.

Peck, Jacqueline K. "Mary Chase Stratton Makes Ceramic History." *Detroit Women's City Club Magazine* (April 1952).

Stratton, Mary Chase Perry. "Ideals of Womanhood Perpetuated in Clay and Glaze." *Michigan Women* (Christmas 1925).

———. "Pewabic Records." *Bulletin of the American Ceramic Society* 25 (October 15, 1946).

Taylor, Marion. "Her Pottery Made Stratton Famous," *Detroit Mirror*, n.d.

Varnum, Mina Humphrey. *Michigan Women* (March 1929).

Letters

Emil Lorch to Mary Chase Stratton, September 18, 1933. Pewabic Pottery.

George Booth letter to Mary Chase Perry Stratton, October 21, 1918. Geo. Booth residence 1-40, Folder 1. Cranbrook Archives, 2009.47.1

Henry Booth letter to C.L. Winder, provost of MSU, October 18, 1978. Henry and Carolyn Booth Papers, Cranbrook Archives, Box 53:7.

Mary Chase Perry Stratton letter to Emil Lorch, April 6, 1949. Pewabic Pottery.

Mary Chase Perry Stratton letter to Henry Booth, October 25, 1926.

Mrs. Albert Nebe letter to Louise Orth, October 13, 1932. Detroit Public Library.

Murray Douglas letter to William Pitney, Professor Emeritus, Wayne State University, circa November 18, 1986. Cranbrook Archives.

Newspapers and Magazines in Electronic Format and Websites

Cranbrook Kitchen Sink. "Photo Friday: Aim High and Go Forth to Serve!" https://cranbrookkitchensink.wordpress.com/tag/kingswood-school.

Golden, Rebecca. "Pewabic Pottery Founder's Grosse Pointe Estate Wants $775K." *Curbed Detroit*, September 2, 2015. http://detroit.curbed.com/2015/9/2/9924840/pewabic-pottery-stratton-house-938-three-mile.

O'Grady, Gerald B., Jr., and Dean Coffin. *Christ Church Cranbrook Visitor's Guide*. Bloomfield Hills, MI: Christ Church Cranbrook, 1982.

Rossi, Monsignor Walter R., Reverend, ed. *Basilica of the National Shrine of the Immaculate Conception Guide and Tour Book*. N.p.: Catholic Church Press, 2007.

University of Michigan. "U of M Honorary Degree: Mary Chase Perry Stratton." Faculty History Project. https://www.lib.umich.edu/faculty-history/faculty/mary-chase-perry-stratton/u-m-honorary-degree.

INDEX

ABOUT THE AUTHOR

Cara Catallo is a writer, editor and copyeditor with experience at the *Detroit Free Press* and the *News & Record* in Greensboro, North Carolina, where she was arts writer and columnist, as well as at various magazines, media outlets and organizations. She previously authored *Images of America: Clarkston*.

Visit us at
www.historypress.net

This title is also available as an e-book